IMAGES
of America

SOUTHERN CALIFORNIA
SURF MUSIC, 1960–1966

ON THE COVER: Dick Dale, "King of the Surf Guitar," and his band, the Del-Tones, hold court at the Harmony Park Ballroom in Anaheim, California, in 1962. This is a scene from a short film commissioned by Capitol Records to help promote Dale nationally. The film was intended for television shows and record hops.

IMAGES
of America

SOUTHERN CALIFORNIA
SURF MUSIC, 1960–1966

John Blair

ARCADIA
PUBLISHING

Published by Arcadia Publishing
Charleston, South Carolina

Printed in the United States of America

Library of Congress Control Number: 2014951924

For all general information, please contact Arcadia Publishing:
Telephone 843-853-2070
Fax 843-853-0044
E-mail sales@arcadiapublishing.com
For customer service and orders:
Toll-Free 1-888-313-2665

Visit us on the Internet at www.arcadiapublishing.com

This book is dedicated to those who were teenagers in Southern California during the early 1960s and whose weekends were spent dancing to surf bands at the Retail Clerks Union Hall Auditorium, Rendezvous Ballroom, Harmony Park Ballroom, Lido Ballroom, and Pavalon Ballroom. I hope this book helps to relive some of those fond memories.

CONTENTS

Acknowledgments 6

Introduction 7

1. The Dawn of Surf Music 9

2. The Early Surf Bands 21

3. The Popularity of Surf Music Explodes 49

4. Beyond the Teenage Fair 99

5. The Women of Surf Music 107

6. Sunset 119

Afterword: A Second Wave 127

ACKNOWLEDGMENTS

I am indebted to the following individuals for providing photographs, information, and technical assistance: Susan Berumen (Orange County Archives), Bob Blankman (First American Corporation), Peggi Collins, Bob Dalley, Art Goddard (Costa Mesa Historical Society), Bob Irwin (Sundazed Records), Aaron Jacobs, Chris Jepsen (Orange County Archives), Paul Johnson, David Lessard, Kathy Marshall, Stephen McParland (payhip.com//CMusicBooks), Randy Nauert, Brian Neal (surfguitar101.com), Jane Newell (Anaheim Historical Society), Richard Siegle (Fender Musical Instruments), Richard Smith (Fullerton Museum), Bob Spickard, Jon Stebbins, and E. Jill Thrasher (Sherman Library and Gardens).

Having studied and written about early 1960s surf music for many years, I know I have forgotten the names of many people who have provided help along the way. So, to all of the musicians, record companies, historians, and discographers, forgive me if I have failed to acknowledge you here. I am indebted to all of you.

Unless otherwise credited, all images are courtesy of the author.

INTRODUCTION

Unlike other forms of American roots music, such as bluegrass, country western, Cajun, or gospel, surf music had its beginning at a very specific geographic location: the beach communities of Southern California. It was here, between the summer of 1960 and the winter of 1961, that a new sound of rock 'n' roll emerged and culturally fused with the mythology of surfing.

On a national level, surf music was primarily represented by vocal groups such as the Beach Boys, Jan & Dean, and Bruce & Terry. Locally, it was the guitar-driven instrumental music of thousands of teenage "garage" bands. It was a musical phenomenon that escalated in intensity, much like early rock 'n' roll from 1956 to 1958.

The originator of the sound that became synonymous with surf music was Dick Dale and his band, the Del-Tones. Hundreds of teenagers converged on the Rendezvous Ballroom in Balboa every weekend by the fall and winter of 1961. The crowds grew until he was attracting several thousand teenagers every night. This level of popularity by a local musician was unheard of at the time.

It was Dale who first used the term "surfing sound" to describe the style of his guitar playing. Since surfing was one of his favorite sports, he attempted to musically reproduce the feeling he had while surfing. The result of this somewhat nebulous and certainly subjective approach was the surfing music genre. The feeling was one of vibration and pulsification, which he produced by a heavy staccato picking of the low-key strings of his guitar, accompanied by a heavy, thunder-like beat. This was his surfing sound, and he allowed it to take an instrumental form.

Between the late 1950s' streetwise rock 'n' roll of Elvis Presley and Chuck Berry and the "safer" teen idol recordings two or three years later by singers such as Bobby Rydell or Frankie Avalon, there was the "golden age of rock instrumentals." The electric guitar became the "lead singer" in a large number of local and national hit records by artists such as Link Wray, Duane Eddy, the Ventures, and the Fireballs. This had a great deal to do with Dale's choice of the instrumental medium to express his "surfing sound," while his admiration for big band drummers such as Gene Krupa and Buddy Rich fueled his use of heavy, dance-tempo rhythms. Dale described it this way: "Surf music is a definite style of heavy staccato picking with the flowing sound of a reverb unit to take away the flat tones on the guitar and make the notes seem endless. Very heavy guitar strings are used to elongate the sound from the vibration of the strings, not the feedback qualities of an amplifier. It becomes a very in-depth combination of things that, when put together, spells out true surf music."

The electronics behind Dick Dale's sound was due to Leo Fender, of Fender Musical Instruments in nearby Santa Ana. He and Dale worked closely for several years to test and improve amplifiers and to develop the Fender Reverb Unit, a device that gave the electric guitar a "wet" sound (imagination required, but the sound of a reverbed guitar is memorable), which quickly became the defining sound of surf music.

Dale would "road test" equipment modifications for Fender at the Rendezvous Ballroom. This collaboration produced and refined the Showman amplifier. Together with its two-speaker model,

the Double (or Dual, as it became known) Showman, these were the most powerful guitar amplifiers on the market for several years.

It was not until the Beach Boys hit the scene in late 1961 that Dale began to move into second place locally. The significance of the Beach Boys' first record, "Surfin'," was that it was not an instrumental, but a song with words about the surfing lifestyle of Southern California. The lifestyle that formed the basis of, and a causal relationship with, surf music had been developing since the 1950s and was, in retrospect, a sociological and cultural phenomenon somewhat exclusive to Southern California. Surf music produced an immediate identity with the teenagers whose lifestyle had reached a point where the music could not only emphasize it, but represent it as well. The music reflected many aspects of this lifestyle, including dress and language.

The mold that the Beach Boys created with their early vocal and harmony-dominated surfing songs attempted to capture that essence of being a teenager and living in Southern California. Their recordings achieved a wide geographic exposure, and "Surfin'" allowed a semblance of the local experience to be vicariously shared by people in other areas of the country and overseas. Soon, instrumental and vocal groups across the country and around the world jumped on the bandwagon. Local scenes developed that were well defined in some cases, though not as integrated as in California.

Dick Dale, the Beach Boys, and Jan & Dean all came from the beach communities of Los Angeles and Orange Counties. So did the Lively Ones, Chantays, Eddie & the Showmen, Blazers, Dave Myers & the Surftones, Adrian & the Sunsets, and scores of others. The boundaries of Orange County stretch to the Pacific Ocean, from Huntington Beach in the north to San Clemente in the south, bracketing nearly 30 miles of prime surfing territory along California's southern coastline.

Nightclub activity in Hollywood, Los Angeles, and even Orange County at the time did not really exist, even if the members of a surf band were old enough to perform in a nightclub (it was not until 1964 that teenage nightclubs began to proliferate, due mainly to the social and musical explosion brought about by the British invasion). So, the early surf bands performed at high schools, civic auditoriums, National Guard armories, and practically any large meeting hall sanctioned for dances by the controlling organization. The first venues to host surf bands were the large meeting halls and ballrooms in Orange County, such as the Retail Clerks Union Hall Auditorium in Buena Park, the Pavalon Ballroom in Huntington Beach, the Harmony Park Ballroom in Anaheim, and the Marina Palace in Seal Beach. In Los Angeles County, there were the Lido Ballroom in Long Beach and the Palladium in Hollywood.

A strong national acceptance of the surf music form was difficult, since it was tied so strongly with the Southern California lifestyle and geography. Between the peak of its popularity in the summer of 1963 and its fadeout several years later, the music was buffeted by political, cultural, and musical events that contributed to its decline. The assassination of John Kennedy cast a dark cloud over all of the fun. The war in Vietnam grew into more of a social and political issue. Closer to home, the Watts riots in 1965 helped to erode more of the idealism. After all, idealism was a very important part of the local image projected in surf music.

However, the Beatles and Motown probably did more to change musical tastes by 1965 than anything else. Southern California's garage bands reacted by either throwing away the Fender Reverb and adding a fuzz-tone to the guitar or by trading in their Stratocaster for a Rickenbacker 12-string. The music turned away from the beaches.

There were several historical components of surf music that not only helped to define the style, but also made it a very unique event both musically and culturally: it was the first time a style of music evolved around a sport, it began as a geographically isolated form of popular music for the most part, and it reflected the lifestyle of a select group of young people. Through the close association of Dick Dale and Leo Fender, the innovations and improvements made to guitar amplifiers had an effect on the industry that lasted far beyond the obsolescence of surf music.

One

THE DAWN OF
SURF MUSIC

Surfing and music, two rather disparate pursuits, culturally merged in 1961 in the beach communities of Southern California. The result was a new genre of popular music that, for a short time, provided the soundtrack for a generation of baby boomers growing up in an optimistic period of economic and cultural stimulation. The music was about going to the beach, surfing, girls, and cars. It was carefree music made by kids, for kids. It was danceable and nonthreatening. It would seem, however, that music and surfing had nothing to do with each other.

The sport of surfing had been practiced for centuries, but it was relatively unknown to the Southern California coastline until the extremely popular 1959 movie *Gidget*. The film was a coming-of-age story about a young girl ("gidget" was short for "girl midget") who becomes enamored, not necessarily of the young men who hang out at her local beach, as her girlfriends are, but of their pursuit of surfing. One reviewer described the film as "an ideal way to usher in the beach season." The movie is considered by many historians as the primary impetus for bringing surfing and its youthful subculture into the American cultural mainstream.

Almost overnight, surfboard sales skyrocketed, and the beach became a typical weekend destination for many teenagers in Southern California. Guys brought their girlfriends to the beach; the girls watched them surf while wearing their new bikinis and working on their suntans. Later in the day, as the ocean breezes picked up, the teens would make a bonfire, bring out the bongo drums and acoustic guitars, and eat hot dogs and s'mores until it was time to head home. For many Southern California teenagers of the time, this was a rite of passage.

Transistor radios, tuned to local Top 40 radio stations, were always brought to the beach. By 1960, the "golden age of rock instrumentals" was in full swing, and the radio blasted hits such as "Guitar Boogie Shuffle" by the Virtues, "Teen Beat" by Sandy Nelson, "40 Miles of Bad Road" and "Rebel Rouser" by Duane Eddy, "Tequila" by the Champs, "Torquay and Bulldog" by the Fireballs, and the most memorable and influential rock instrumental of all, "Walk Don't Run" by the Ventures. But there was still nothing called "surf music."

Surfing movies had been made since the 1940s, but they were silent, 16-millimeter documentary films made by a handful of filmmakers to showcase the sport. Early filmmakers such as Bud Browne, John Severson, Greg Noll, and Bruce Brown established the format for the many films that followed. Each movie featured a number of surfing montages from California, Hawaii, Mexico, or Australia, some staged comedic sequences, and entertaining live narration, usually by

the filmmaker himself. These were shown to surfing-minded audiences at high schools, meeting halls, or small, independent movie theaters in California coastal communities.

There were no soundtracks. Instead, the filmmaker/narrator would play a record or a prerecorded tape at a low volume behind his narration. These were typically instrumental recordings that paired well with the visual excitement shown on the screen. In the beginning, jazz or orchestrated recordings were used, such as those by Bud Shank or Henry Mancini. By 1960, however, many of the surfing movie filmmakers were using rock instrumental records for their live "soundtracks"; an artistic connection began between surfing and instrumental rock music.

That connection appears to have been formalized in 1961 by those who came to see Dick Dale & the Del-Tones at the Rendezvous Ballroom in Balboa, and by those who came to see the Bel-Airs play at the Bel Air Club in Redondo Beach farther up the coast. Dale has credited his early Rendezvous audiences (many of whom were avid surfers) with using the term "surfing sound" to describe his band's music. Guitarist Paul Johnson of the Bel-Airs remembers a surfer who approached him in the summer of 1961 and said, "Wow, man—your music sounds just like it feels out there on a wave! You should call it 'surf music'."

Gidget was released by Columbia Pictures on April 10, 1959. The movie was based on the novel *Gidget, the Little Girl with Big Ideas* by Frederick Kohner about his daughter Kathy's exploits in Malibu with the surfing culture that existed at the time. It was the first major Hollywood film to feature the sport of surfing as an integral part of the plot. Gidget, played by actress Sandra Dee, wanted to become a surfer and be accepted by the local Malibu surfing community. Despite lukewarm reviews, the movie was wildly successful and brought national attention to surfing and to the California beach lifestyle. In the photograph below, Kathy Kohner (left) and Sandra Dee relax on the set of *Gidget* at Leo Carrillo State Beach in Malibu, California. (Below, courtesy of Kathy Kohner.)

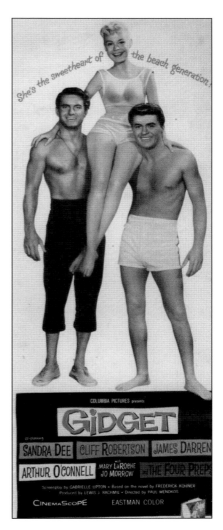

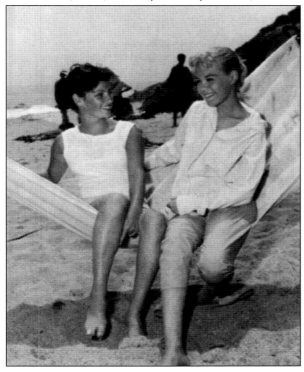

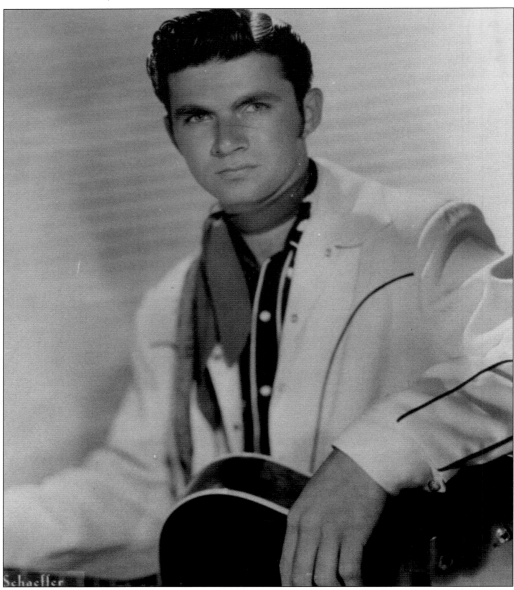

Schaeffer

Jim Monsour's family moved from Massachusetts to the Los Angeles area in the mid-1950s. There were new career opportunities in Southern California, brought about by the explosive postwar growth of the aircraft industry, and Monsour had been hired by Hughes Aircraft. His son, Richard, fresh out of high school, played guitar and sang, leaning toward country music, as indicated by this very early promotional photograph. He developed an Elvis Presley imitation that helped him win a few talent contests. However, he soon changed his name to Dick Dale at the suggestion of radio disc jockey T. Texas Tiny, who felt the shorter and more alliterative name would make it easier to sign autographs. A brief example of Dick Dale's Elvis imitation from the time can be seen in his appearance during the opening minutes of the 1960 film *Let's Make Love* with Marilyn Monroe.

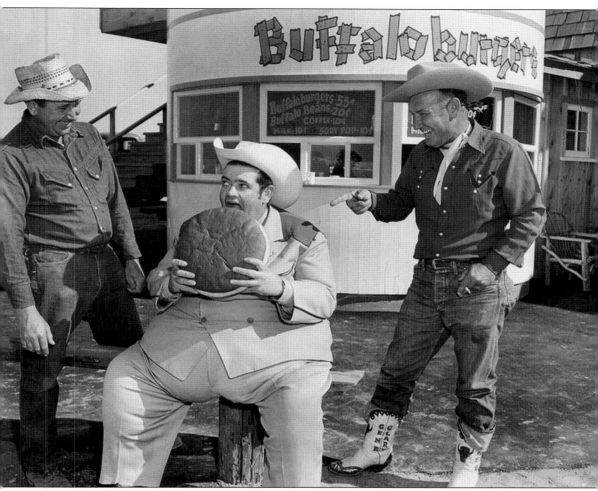

Around 1958, Richard Monsour met a country-western radio disc jockey from Gardena named T. Texas Tiny, who told him that he should change his name if he wanted a career in music. The name *Dick Dale* was suggested. In this 1955 photograph, T. Texas Tiny takes a bite from a plus-sized hamburger on the site of the Newport Harbor Buffalo Ranch. On the right is Gene Clark, owner of the ranch. At left is an unidentified ranch hand. (Courtesy of Orange County Archives.)

This 1975 photograph shows the site of the Rinky Dink Ice Cream Parlor at 117 Main Street in Balboa, California. In a 1960 *Los Angeles Times* article, columnist Art Ryon wrote, "Right in the center of Balboa is the red-and-white striped Rinky Dink Ice Cream Parlor and Ice Cream Night Club . . . how many times have YOU ever gone to an ice cream night club?" This was where Dick Dale and his cousin Ray Samra started to perform as a duo on weekends shortly after it opened in 1959. Within a few months, they had started to attract so many teenagers that the crowd overflowed into the street and the owner, Tom Carollo, had to ask Dale to leave. He moved to the Rendezvous Ballroom, a block away. An electrical fire on November 7, 1960, caused the Rinky Dink to close its doors. It reopened a few weeks later as an Orange Julius franchise. (Courtesy of Orange County Archives.)

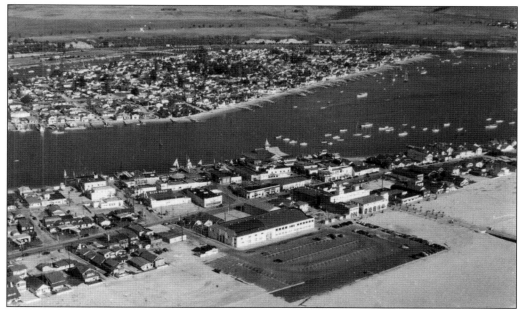

The Rendezvous Ballroom in Balboa, California, was built in 1928 and had a 12,000-square-foot dance floor that could accommodate up to 1,500 couples. It was dubbed the "Queen of Swing" by *Look* magazine and for years hosted bandleaders such as Stan Kenton, Benny Goodman, Harry James, and Woody Herman. Dance concerts with popular vocalists of the time were broadcast on national radio. By the late 1950s, the ballroom had gone quiet and was used infrequently for dances. Dick Dale & the Del-Tones began their residency here around July 1, 1960, bringing life and music back to the venue. (Courtesy of the Costa Mesa Historical Society.)

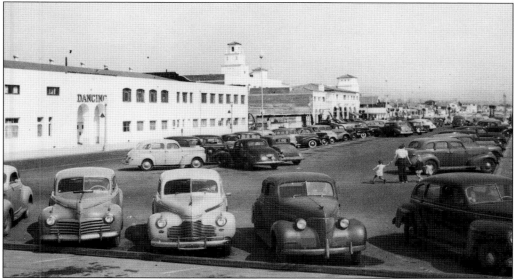

This 1930s photograph of the Rendezvous Ballroom leaves no doubt that dancing was the main reason for coming there, whether the music emanating from inside was big band or surf band. It has been said that, during high tides, a large wave would sometimes push a small amount of water into the parking lot. (Courtesy of the Orange County Archives.)

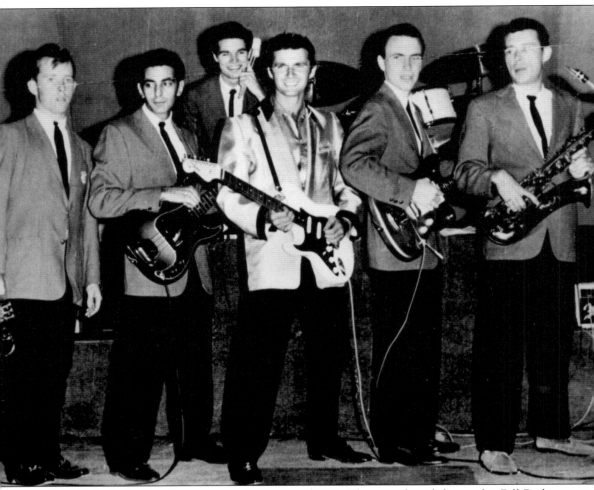

Dick Dale & the Del-Tones are seen here around 1961. They are, from left to right, Bill Barber (saxophone, trumpet), Ray Samra (bass), Jack Lake (drums), Dick Dale (guitar), Nick O'Malley (guitar), and Russo "Skid" Guartny (saxophone). The band's lineup changed fairly often as Dale developed the sound and style that would soon become known as "surf music." The band played at the Rendezvous Ballroom between July 1960 and the end of December 1961. For much of that time, Dale attracted several thousand teenagers every night.

"Let's Go Trippin'" was not Dick Dale's first record, but it is considered by many historians to be the first surf instrumental recording. It was recorded on August 23, 1961, and it climbed to No. 60 on the *Billboard* Top 100 chart several weeks later. The title refers to a slang term used by those who "tripped down to the Rendezvous" to hear Dick Dale & the Del-Tones on weekends. Deltone Records was owned by Dale's father, Jim Monsour.

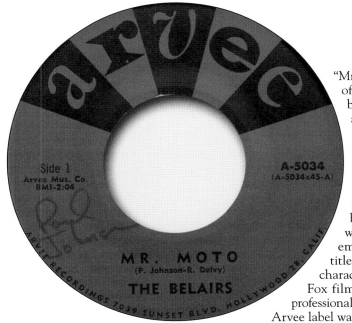

"Mr. Moto," also from the summer of 1961, was the first recording by the Bel-Airs (often seen as the "Belairs" or "Bel Airs" on record labels or concert posters). This song, together with "Let's Go Trippin'," are considered the first recorded examples of instrumental surf music. In addition, the two bands responsible for the songs were critically important to the emergence of surf music. The title refers to both the Peter Lorre character in a series of 20th Century Fox films of the 1930s and a popular professional wrestler of the early 1960s. The Arvee label was owned by Richard Vaughn.

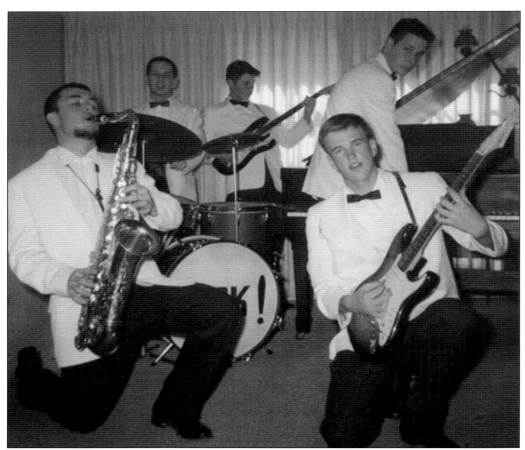

Above are the Bel-Airs in early 1961. Clockwise from lower left are Chaz Stuart, Richard Delvy, Eddie Bertrand, Jim Roberts, and Paul Johnson. Named after the 1955 Chevrolet Bel Air, the band was from the South Bay area of Southern California. The Bel-Airs started to rent local halls (such as Knights of Columbus or Elks halls) for weekend dances and found an audience that seemed to grow in numbers into the summer of 1961. Below is a rare live photograph of the band performing at a high school dance in 1962. From left to right are Chaz Stuart, Paul Johnson, Dick Dodd, and Eddie Bertrand. (Both, courtesy of Eddie Bertrand.)

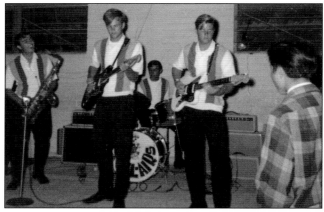

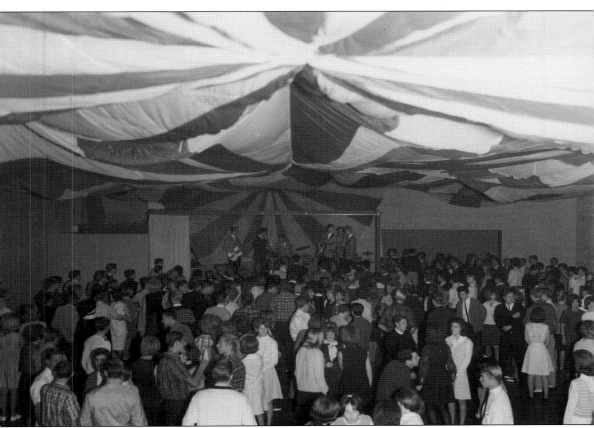

The Bel Air Club at 312 South Catalina Avenue in Redondo Beach was opened as a teenage dance club in mid-1962, with the Bel-Airs as the resident house band. It quickly became the center of the South Bay music scene and existed for several years, undergoing two or three name changes. The club was bought in 1963 by KRLA disc jockey Reb Foster, and the name was changed to the Revelaire Club. From the summer of 1962 through early 1964, the club was an important venue, not just for the Bel-Airs, but for quite a few of the area's surf bands, including Eddie & the Showmen (pictured), the Revelaires, Thom Starr & the Galaxies, the Vibrants, and the Crossfires. (Courtesy of Peggi Collins.)

Balboa Hops To Continue

Dancing at the Rendezvous Ballroom will continue Friday and Saturday nights throughout the winter season, according to its management, the American Ballroom Corp.

Dick Dale and the Del-tones, featured at the ballroom this summer, will continue to play for the winter schedule During the week, the group will be in Hollywood for motion picture and television assignments.

Dale appears briefly in Marilyn Monroe's new picture "Let's Make Love."

The weekend dances are scheduled 8 p.m. to midnight. Dress is informal. Since most of the crowd are students, the dances were limited to weekends, the management said.

At left, a local newspaper article from October 14, 1960, indicates a tentative approach to reopening the Rendezvous Ballroom earlier that summer for weekend dances. City fathers were concerned about crowd control as a result of allowing rock 'n' roll dances at the venue. For several months, the dances had been held without many problems for area residents or the city, so the weekend dances were allowed to continue into the fall and winter. Below is an advertisement for Easter week 1961 at the Rendezvous Ballroom. Dancing at the ballroom was from 8:00 p.m. until midnight. The flipside of Dick Dale & the Del-Tones' most famous single, "Miserlou," was an instrumental titled "Eight Till Midnight." By the time Bal Week (as Easter week was called in Balboa) of 1961 came around, several thousand teenagers were converging on the Rendezvous Ballroom every Friday and Saturday night. (Both, courtesy of the *Newport Beach Daily Pilot.*)

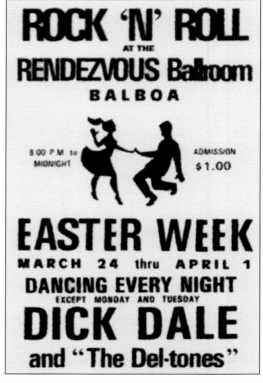

Two

THE EARLY SURF BANDS

The Rendezvous Ballroom in Balboa, California, had fallen on hard times by the late 1950s. City fathers considered closing the venue for good until Dick Dale offered strict dress and behavior standards for his nightly dances. In a March 1961 newspaper article, Dale said: "We have a closed door policy. Two men stand at the entrance and check the kids' appearance. If they don't look presentable, they're turned away. . . . Inside, four security police patrol all evening and a policewoman checks the girls' dressing room to make sure there's no drinking there. . . . This works great, but what really cured the trouble at the Rendezvous where it always started is our new rule for the parking lot. Once you're in the ballroom, you may not leave and come back without paying a second $1 admission." This policy essentially kept the city from revoking the ballroom's business license, and dances were allowed to continue.

Dale's band, the Del-Tones, included piano and three saxophones besides the usual rock 'n' roll combo of guitar-bass-drums. That helped to create a huge, full sound that nearly buried the guitar within the cavernous Rendezvous Ballroom. In the summer of 1960, Dale searched for a louder guitar amplifier. He approached Leo Fender of nearby Fender Musical Instruments. In the following months, they worked to develop the Showman amplifier and a host of other innovative products, including the Fender Reverberation (or Reverb) Unit. Both the Showman and the Reverb, together with Fender guitars (the Stratocaster or Jaguar were the models of choice), quickly became staples among surf bands. Fender guitars and amplifiers essentially defined the sound of surf music from the beginning.

Both Dick Dale in Balboa and the Bel-Airs a few miles farther up the coast inspired a lot of teenagers in Southern California to pick up musical instruments and to start their own bands. Dale, however, was the primary source of inspiration. In his own words, "Surf music is a definite style of heavy staccato picking with the flowing sound of a reverb unit to take away the flat tones on the guitar and make the notes seem endless. Very heavy guitar strings are used to elongate the sound of the vibration of the strings, not the feedback qualities of an amplifier. It becomes a very in-depth combination of things that, when put together, spells out true surf music."

Paul Johnson of the Bel-Airs has been quoted as saying, "It was a powerful experience; [Dale's] music was incredibly dynamic, louder, and more sophisticated than the Bel-Airs, and the energy between the Del-Tones and all of those surfers stomping on the hardwood floor [of the Rendezvous] in their sandals was extremely intense. The tone of Dale's guitar was bigger than any I had ever heard, and his blazing technique was something to behold." It was a feeling shared by everyone who came to see Dale perform at the Rendezvous and one of the reasons why he attracted thousands to his dances. That kind of attention was unheard of in Southern California at that time.

Although Dick Dale was in his mid-20s, this was music for teenagers, performed by teenagers. As such, surf bands were intimately connected to area high schools. Initially, high school dances and

assemblies provided exposure for the music. Quickly, though, the music moved into the community, as teen clubs were formed and dances were held at area union halls and auditoriums.

Dick Dale & the Del-Tones moved to Anaheim's Harmony Park Ballroom and began to play weekend dances there in early 1962. The music was still drawing very large crowds, so it was not long before weekend dances (or "surf stomps," as many of them were becoming known) were held in larger venues, such as the Retail Clerks Union Hall Auditorium (Buena Park) or the Pavalon Ballroom (Huntington Beach).

Promotion became part of a band's responsibility if it wanted to continue to find gigs. A common practice was for a band to record and press its own 45 rpm record. A great many surf bands did this, generally pressing no more than 500 or 1,000 copies and selling them at personal appearances. Having one's record played on a local radio station was the ultimate goal.

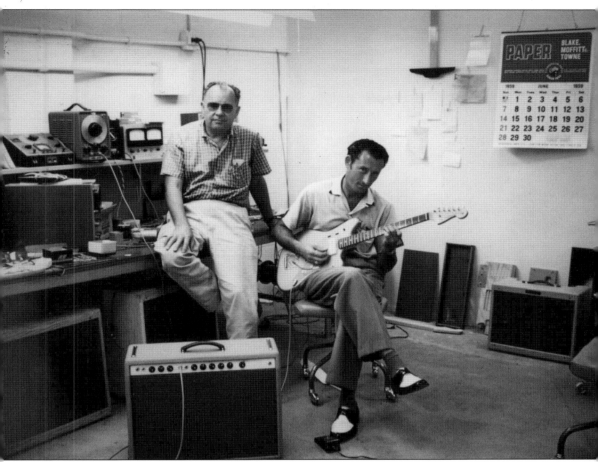

Leo Fender (left) poses in his workshop at Fender Musical Instruments in Fullerton, California, in June 1959 (as indicated by the calendar on the wall). Seated and playing one of Fender's new Jazzmaster model guitars is Luther Perkins, a longtime member of Johnny Cash's backing band and the man responsible for Cash's distinctive, muted rhythm guitar sound. Besides country and rockabilly music, Fender guitars and amplifiers were extremely important to the sound and development of surf music. Fender gave Dick Dale a Stratocaster around this time, beginning a long relationship that culminated in the development of several Fender products in 1960 and 1961, most prominent being the Dual Showman amplifier and the Reverb Unit. Dale used his tenure at the Rendezvous Ballroom to "road test" various Fender products. As a result, Fender guitars and amplifiers became the most preferred by surf bands. (Courtesy of Fender Musical Instruments.)

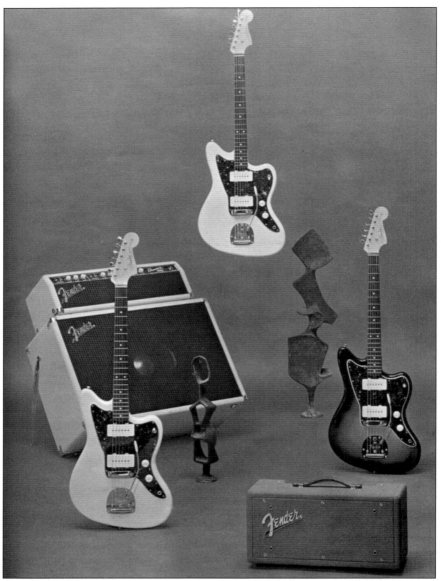

This page from the 1961–1962 Fender Musical Instruments product catalog was the first appearance of Fender's Reverb Unit (the brown "box" at lower right). This is actually a prototype unit; commercial units had a grill cloth panel on the front instead of the wood panel shown here. According to John Teagle and John Sprung in their book *Fender Amps: The First Fifty Years*, "The Hammond Organ Company had developed the spring reverb to enhance the sound of the electric organ . . . so companies like Fender who wanted to offer reverb to their customers licensed the Hammond design." This electronic effect device (connected between the electric guitar and amplifier) was eventually used by most teenage surf bands to create the classic sound of surf guitar. That sound has been described over the years as giving an electric guitar a "wet" or "splashy" sound. Dick Dale tested this device for Leo Fender at the Rendezvous Ballroom, as well as the Showman amplifier (shown in this Fender product catalog) and other Fender products. Also shown here are three Fender Jazzmaster guitars. (Courtesy of Fender Musical Instruments.)

INCREASED PROFITS WITH NEW FENDER PRODUCTS

THE NEW FENDER BASS GUITAR

Every musician will readily recognize the potential of the New Fender six-string Bass Guitar inasmuch as it offers an entirely "new sound" to every playing group. Tuned one octave below the standard guitar, numerous new tone combinations are made possible with three full range pickups. The circuit incorporates three two-position switches enabling the player to select the pickups individually or in any combination. In addition, a tone control positioned adjacent to the volume control permits further tone modifications of any selector position. The Bass Guitar is a fine addition to the Fender line and answers the demand for a high-quality six-string bass.

FENDER REVERBERATION

The New Fender Reverberation Unit is designed for use with all applification systems and offers the finest distortion-free reverberation. It is highly portable and provides the "expanded sound" effect sought by guitarists and accordionists. In addition, it is an excellent unit for microphone, phonographs and tape recorded program material.

The Fender Reverberation Unit employs a professional amplifier section plus the popular Hammond Reverberation adapter. It can be used with the player's amplifier to provide normal sound amplification to which reverberation may be added by use of the remote on-off reverberation foot pedal. The circuit includes a Tone Control and Mixing Control at the instrument input. The separate Duration Control provides any degree of reverberation desired by the player.

Every musician desiring the latest and finest portable professional reverberation equipment will find this new Fender Unit to be unsurpassed in design and construction. Comparison will prove it to be unexcelled in over-all performance.

VIBROLUX AMP

The new Vibrolux Amp features a fine Tremolo circuit assuring top amplification qualities and performance characteristics. The circuit incorporates the latest control and audio features to make it the finest amplifier of its type in its price class.

DELUXE AMP

The newly designed Deluxe Amp is outstanding in its price class and incorporates the following features: Front panel, Two channels, Tremolo, Two volume controls, Two tone controls, Speed and Intensity controls, 12" heavy-duty speaker. An exceptional performer in its price range and represents one of the finest values available.

The Princeton Amp, available separately and with the Studio Deluxe Set, now features Vibrato and front panel controls. The Duo Sonic (pictured above) and Musicmaster guitars are now finished in the new Shaded Sunburst Finish.

Fender
SALES, INC.

SANTA ANA, CALIFORNIA

A Fender sales sheet from late 1961 illustrates four new products for the sales team to emphasize with customers. Besides a couple of amplifiers and the new Bass VI guitar (a six-string bass, usually tuned an octave below a normal guitar), the production "Reverberation" unit is pictured. The sales-slanted text is laden with adjectives that do little to describe the actual, "wet" sound of this device (accordionists were surely a minor marketing audience!). Regardless, there may not have been instrumental surf music without the iconic Fender Reverberation (or Reverb). It was used on so many instrumental recordings, and by so many surf bands, that its sound became intertwined with the "sound of a surf guitar" (the Chantays' "Pipeline" is a classic example). (Courtesy of Fender Musical Instruments.)

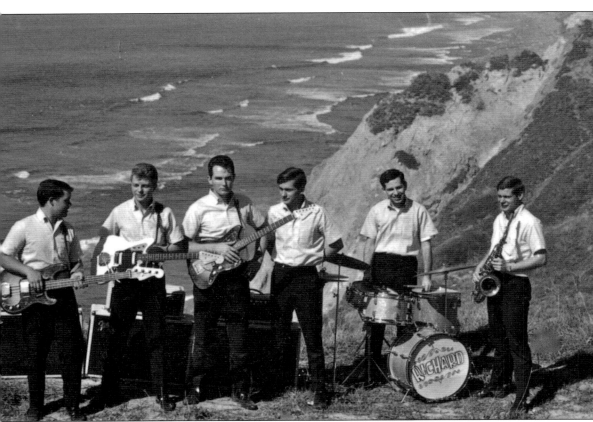

The Challengers was one of the earliest surf instrumental bands in Southern California. Richard Delvy and Jim Roberts formed the band out of their first group, the Bel-Airs. Because of its many recordings and local television appearances, the band became one of the most ubiquitous and visible surf bands in the area through 1964 and 1965. In this promotional photograph taken by Ray Avery, the Challengers pose on the Palos Verdes peninsula cliffs in the summer of 1962. The band's lineup changed a few times during the several years they were together, but this is the original group. Shown here are, from left to right, Randy Nauert, Glenn Grey, Don Landis, Jim Roberts, Richard Delvy, and Nick Hefner. (Courtesy of Randy Nauert.)

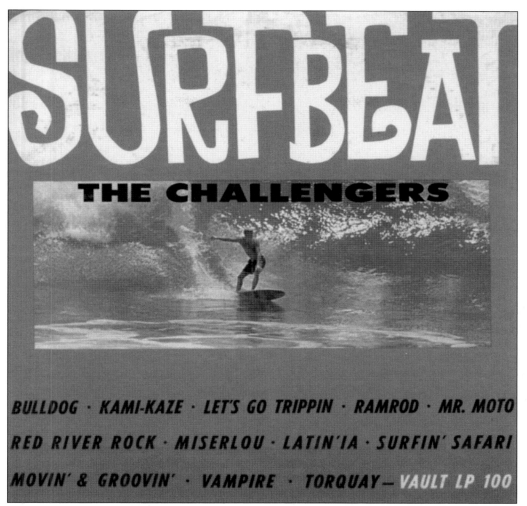

BULLDOG · KAMI-KAZE · LET'S GO TRIPPIN · RAMROD · MR. MOTO

RED RIVER ROCK · MISERLOU · LATIN'IA · SURFIN' SAFARI

MOVIN' & GROOVIN' · VAMPIRE · TORQUAY — VAULT LP 100

The Challengers' *Surfbeat* album was released in October 1962. It was one of the first two or three surf albums to hit record store shelves, and it sold exceptionally well. Promotional copies were pressed on clear yellow vinyl to help draw the attention of radio disc jockeys. All of the tracks were covers of earlier recordings by the Bel-Airs, Duane Eddy, the Fireballs, the Sentinals, Johnny and the Hurricanes, and even Dick Dale. Interestingly, the track "Surfin' Safari" was a vocal track on the album's first pressing. Subsequent pressings used an instrumental version of this Beach Boys' song.

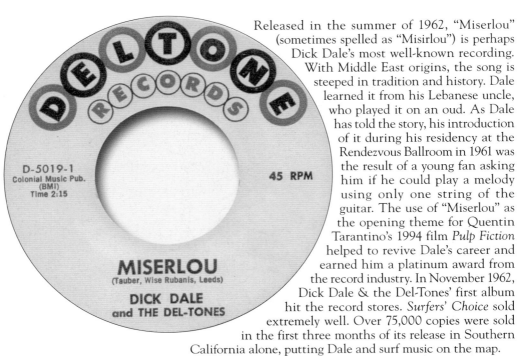

Released in the summer of 1962, "Miserlou" (sometimes spelled as "Misirlou") is perhaps Dick Dale's most well-known recording. With Middle East origins, the song is steeped in tradition and history. Dale learned it from his Lebanese uncle, who played it on an oud. As Dale has told the story, his introduction of it during his residency at the Rendezvous Ballroom in 1961 was the result of a young fan asking him if he could play a melody using only one string of the guitar. The use of "Miserlou" as the opening theme for Quentin Tarantino's 1994 film *Pulp Fiction* helped to revive Dale's career and earned him a platinum award from the record industry. In November 1962, Dick Dale & the Del-Tones' first album hit the record stores. *Surfers' Choice* sold extremely well. Over 75,000 copies were sold in the first three months of its release in Southern California alone, putting Dale and surf music on the map.

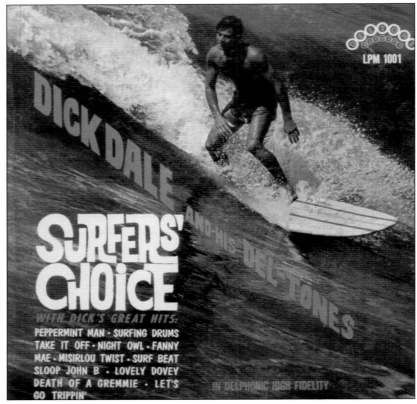

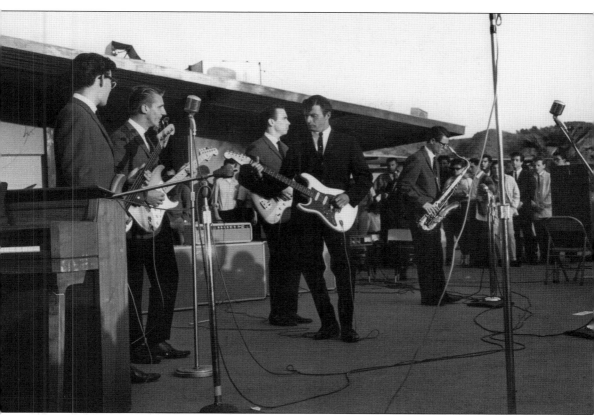

The first Teenage Fair was held at Pacific Ocean Park in Santa Monica in April 1962. Held annually for 11 years, the 10-day-long event provided music, surfing clinics and movies, hot-rod shows, amusement rides, fashion shows, dance contests, and the Miss Teen USA beauty pageant, among other features and attractions of interest to teenagers. Each year, the Teenage Fair attracted several hundred thousand people, making it one of the paramount social and cultural events in Southern California that helped to expose and promote surf music. Here, Dick Dale & the Del-Tones perform at the second Teenage Fair in April 1963 at the Pickwick Recreation Center in Burbank. (Photograph by Robert Perine, courtesy of Fender Musical Instruments.)

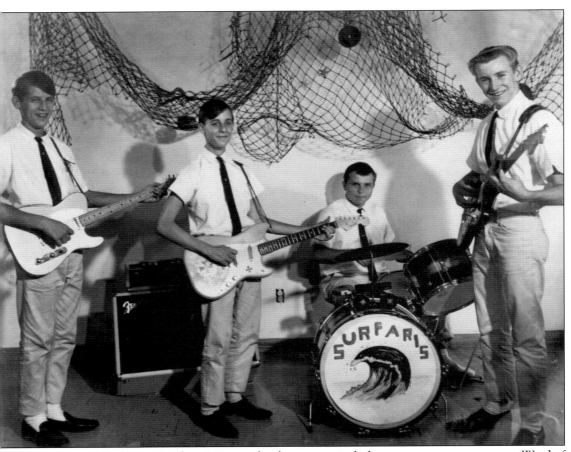

By the fall of 1962, "surf music" started to become a catchphrase among area teenagers. Word of Dick Dale's shows had spread inland 50 or 60 miles. In fact, KMEN in San Bernardino—situated at the westernmost edge of the Mojave Desert, about as land-locked as one can get—was the first radio station to play Dale's records. The Surfaris, one of the earliest of these "inland" surf bands, ended up creating one of the most recognizable surf instrumentals, "Wipe Out." Shown here in September 1962 are, from left to right, Pat Connolly, Jim Fuller, Ron Wilson, and Bob Berryhill. Saxophonist Jim Pash, who joined the band after this photograph was taken, is not shown. Wilson, 17, was the oldest in the band; the others were 14 years old. They were from West Covina, about 45 miles east of the Orange County beach cities. (Courtesy of Bob Berryhill.)

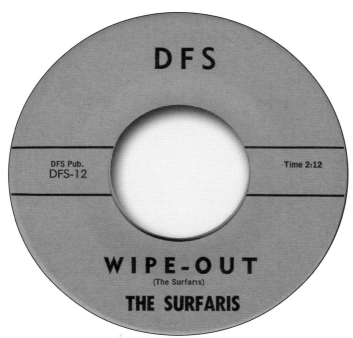

The Surfaris' big hit was an afterthought. They had gone to a recording studio in December 1962 to record a vocal, "Surfer Joe." Because a second recording was needed for the flipside if they were going to release a single, "Wipe Out" was created on the spot and completed in a single take. It was based on a marching cadence the drummer played in his high school marching band, coupled with a guitar riff inspired by an earlier Duane Eddy recording. "Wipe Out" went to No. 2 on the *Billboard* Top 100 chart in July 1963.

THE SAHARA TEEN CLUB ONTARIO
DANCE
EVERY FRI. & SAT. NITES 8 to 12

WHERE THE TOP BANDS APPEAR

Just To Mention A Few . . .
★ **THE TORNADOES**
★ **JOHNNY FORTUNE**
★ **THE CORDELLS** ★ **CHANTAYS**
★ **SURFARIS**
★ **ROD and THE DRIFTERS**
★ **JIMMY and The Rhythm Surfers**
★ **And Many, Many More!** ★

ADMISSION ONLY $1.00
DANCE CONTEST DOOR PRIZES

For a Real Good Time . . .
Come and Meet Your Friends at The Sahara

1306 W. BROOKS – Off Mountain Avenue

Balboa's Rinky Dink Ice Cream Parlor (where Dick Dale started playing regularly in 1959) was tagged by *Life* magazine in the summer of 1960 as "the only teenage nightclub in the nation." By the end of 1962, as the sound of surf music started to spread, local teen clubs began to appear throughout Southern California. They provided alternative gathering places for teenagers to be on a Friday or Saturday night without having to drive a considerable distance to see their favorite bands at one of the larger ballrooms in Orange County. The Sahara Teen Club in Ontario was typical of the growing teenage nightclub scene in Southern California.

| AERTAUN ENTERPRISE DANCES |

THE

- GREATEST -

In Summertime Fun and Dancing

The Best of Southern Calif. Rockin' Bands

★ **DICK DALE & The Deltones** ★

★ **VENTURES** ★ **BELAIRS**

BEACHBOYS **VIBRANTS**

TORNADOS **BISCAINES**

FOLLOW THE SEARCHLIGHTS

EVERY SAT. NITE 8 P.M.
AT THE SPACIOUS

ONTARIO NATIONAL GUARD ARMORY
JOHN GALVIN PARK

Bands would often rent a social or union meeting hall for weekend dances. The use of National Guard armories, Elks Club lodges, roller-skating rinks, and veterans' halls became more commonplace as 1962 unfolded and surf music gathered momentum. This flyer does not refer to a specific dance but was used to promote Aertaun Enterprises, a business established by Dave Aerni and George Taunton to produce and promote artists (most of whom were surf bands) in the Inland Empire, primarily San Bernardino and Riverside Counties.

The Biggest Stomp Ever

☆ **FOUR BANDS** ☆

FEATURING THE FABULOUS

"BEL AIRS"

★ **MR. MOTO** ★

ALSO STARRING

"THE JOURNEYMEN"
"THE VIBRANTS"
"THE PENDLETONS"

TORRANCE ROLLER DROME

MULLEN STREET and TORRANCE BLVD.

Friday Nite, May 18th

8 p.m. 'til ?

★ DOOR PRIZES
★ FIRST 10 ADMITTED FREE
★ RECORDS GIVEN AWAY FREE
★ SURF BOARDS AND TEE-SHIRTS FREE
★ TROPHYS AWARDED

Come As You Are
Follow The Search Lights

Anywhere with a stage and enough room for several hundred teenagers to dance provided a suitable venue for surf bands to perform. It was not always a single promoter who found a location and put up the money to rent the room for a night; frequently, the bands did this. Many dances were quite the affair, with searchlights, door prizes, a soft drink fountain, and sometimes, hamburgers and hot dogs. The Torrance Roller Drome "stomp" was held on May 18, 1962.

DANCE - *Two Big Nights!*

THURSDAY, July 12

Mike Patterson and the

RHYTHM ROCKERS

FRIDAY, July 13

The Original "MR. MOTO"

BELAIRS

AMERICAN LEGION HALL

Third & Birch Sts.

NO LEVIS # Santa Ana

Mike Patterson & the Rhythm Rockers, from Santa Ana, became the house band at the Rendezvous Ballroom following Dick Dale's departure at the end of December 1961. The Bel-Airs, from the South Bay area a few miles north, had already established themselves as one of the area's best bands and had received local radio airplay for "Mr. Moto." This two-night dance at the American Legion Hall in Santa Ana was in July 1962.

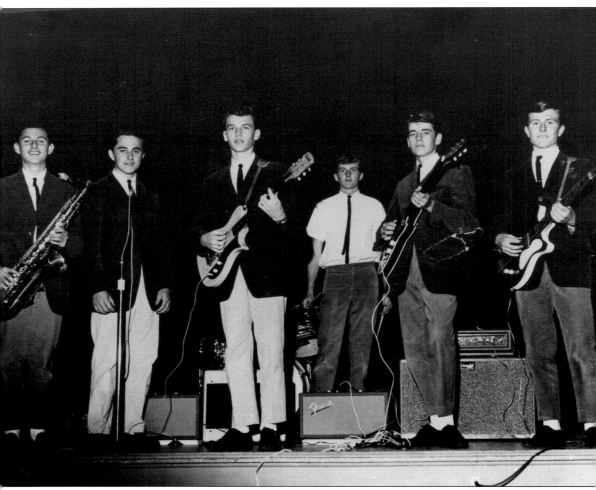

The Chantays formed in Santa Ana, California, in late 1961. They were inspired by the Rhythm Rockers, another local band who put on a dance every weekend at the Santa Ana Community Center. The Chantays rented a local youth center for their first gig in December 1961, printing and distributing their own posters and handbills. This entrepreneurial spirit was shared by many of the early surf bands. The Chantays recorded "Pipeline" while the members were still in high school. The record took off, and the band was soon appearing on television programs, including the nationally syndicated *Lawrence Welk Show* in May 1963. They were the only surf instrumental band at the time that toured in Japan (in late 1965 and early 1966). Shown here are, from left to right, Jim Frias, Bob Marshall, Bob Spickard, Bob Welch, Brian Carman, and Warren Waters. (Courtesy of Bob Spickard.)

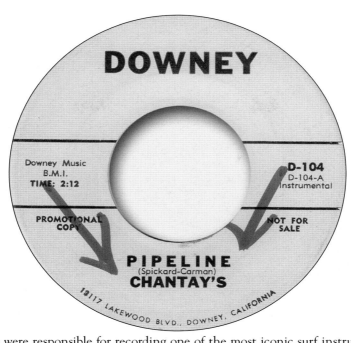

DOWNEY

Downey Music
B.M.I.
TIME: 2:12

D-104
D-104-A
Instrumental

PROMOTIONAL
COPY

NOT FOR
SALE

PIPELINE
(Spickard-Carman)
CHANTAY'S

13117 LAKEWOOD BLVD., DOWNEY, CALIFORNIA

The Chantays were responsible for recording one of the most iconic surf instrumentals of the 1960s, "Pipeline." The original composition was named after the famous (and dangerous) surfing spot on the North Shore of Oahu, Hawaii. The instrumental breached the national Top 10 in the spring of 1963 and won a BMI Citation of Achievement award that year. Along with Dale's "Miserlou" and the Surfaris' "Wipe Out," "Pipeline" is one of a handful of surf instrumentals from the 1960s that are instantly recognizable today.

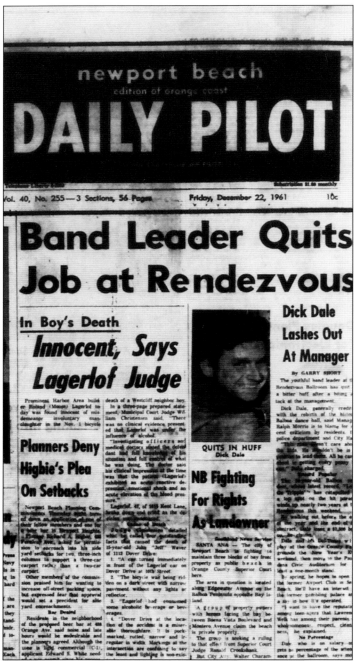

Dick Dale's nearly two-year residency at the Rendezvous Ballroom ended on December 23, 1961. Weekend crowd control along the entire three-mile length of the Balboa peninsula had become a headache for the city, so there was a lot of pressure on the city council and on the Rendezvous management to close the ballroom. The ballroom did close for a short time, but it resumed dances a few weeks later when the Rhythm Rockers became the new house band. (Courtesy of the *Newport Beach Daily Pilot*.)

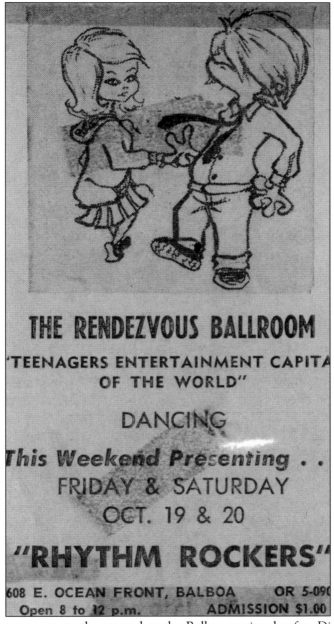

THE RENDEZVOUS BALLROOM

"TEENAGERS ENTERTAINMENT CAPITA
OF THE WORLD"

DANCING

This Weekend Presenting . .
FRIDAY & SATURDAY
OCT. 19 & 20

"RHYTHM ROCKERS"

608 E. OCEAN FRONT, BALBOA OR 5-090
Open 8 to 12 p.m. ADMISSION $1.00

Calm and quiet were apparently restored to the Balboa peninsula after Dick Dale, and his hundreds of fans, left the Rendezvous. Dances at the ballroom continued, but with much smaller crowds, as the management tried to keep the venue open and profitable. The Rhythm Rockers got the job as the new resident band. This was a veteran, seven-piece rock 'n' roll dance band that started in Santa Ana in 1958, backed up many touring lead vocalists at live performances, and developed a lengthy repertoire as a result. As they rolled into the Rendezvous in early 1962, surf instrumentals were certainly part of that repertoire. This October 1962 handbill announces the Rendezvous Ballroom as the "Teenagers Entertainment Capital of The World." (Courtesy of Douglas Worley.)

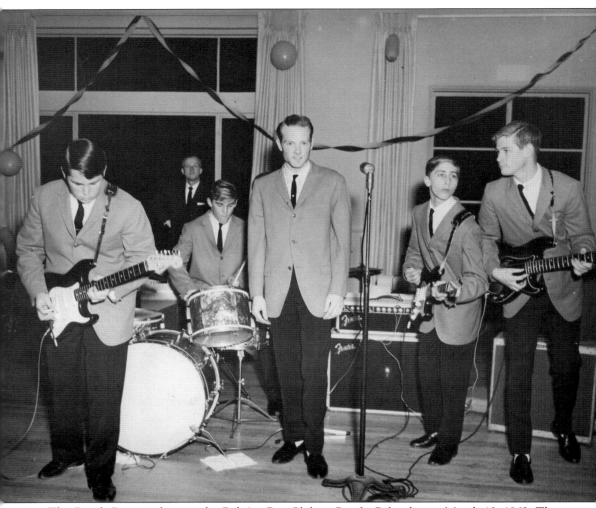

The Beach Boys perform at the Bel Air Bay Club in Pacific Palisades on March 10, 1962. The band members are, from left to right, Carl Wilson, Dennis Wilson, Mike Love, David Marks, and Brian Wilson. It was drummer Dennis Wilson who suggested that Brian write a song about surfing. Dennis, the only one in the band who surfed, recognized it as a growing trend among teenagers. The band gathered in a small Los Angeles studio in the fall of 1961 and recorded the anthemic "Surfin'" ("Surfing is the only life, the only life for me"). The record debuted on the *Billboard* charts in February 1962, and the band was on their way. Al Jardine, who played on this first single, left the band (but would return in 1963) and was replaced by David Marks. The Beach Boys' first public performance happened to have been during intermission at Dick Dale & the Del-Tones' last show at the Rendezvous Ballroom, on December 23, 1961. (Courtesy of David Marks.)

At the time of their first single, the band called themselves the Pendletones (named after Pendletons, the popular wool shirts), but the record company changed it to the Beach Boys at the 11th hour. "Surfin'" quickly climbed the local charts until it was in the Top 10 of Southern California radio stations, ultimately reaching the No. 75 position nationally in March 1962. Unhappy with the lack of promotion by Candix, the Beach Boys decided to shop their next recording to other labels. They were soon picked up by Capitol Records, who released their second single, "Surfin' Safari" and "409," in June 1962. A lot of the surfers who were part of the core audiences at shows by Dick Dale, the Bel-Airs, and other instrumental surf bands did not like the Beach Boys' vocal approach. They were considered amateur poseurs. That would quickly change.

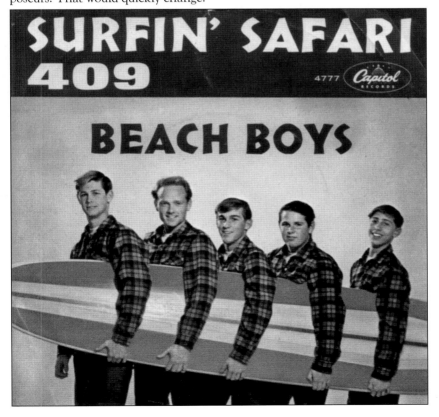

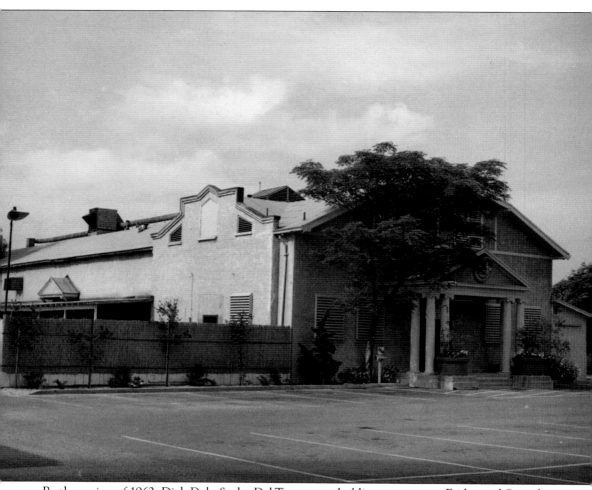

By the spring of 1962, Dick Dale & the Del-Tones were holding court every Friday and Saturday night at the Harmony Park Ballroom in nearby Anaheim, at 1514 West Broadway. The ballroom was built in 1922 with a capacity of about 816 people and parking for up to 73 cars. Although not as well known as the Rendezvous Ballroom, nor as big, Harmony Park was steeped in music history, having hosted big bands in the 1930s and 1940s. (Jack Benny was reported to have performed there.) In the late 1950s, rock 'n' roll and rhythm and blues shows were held there; in fact, the song "Louie Louie" was written by Richard Berry at the venue one night in 1955 after he performed with the Rhythm Rockers. (Courtesy of the Anaheim Public Library.)

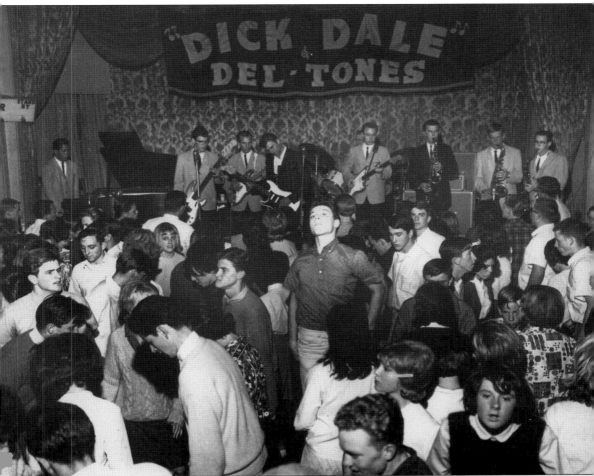

Dick Dale & the Del-Tones perform at the Harmony Park Ballroom in Anaheim in 1962. Once Dale brought his band to Harmony Park, it quickly became another popular Friday and Saturday night destination for dancing (as well as on Sunday and Wednesday nights). Dale shared the stage on off nights with Dave Myers & the Surftones. Note the "On Air" sign above the stage. For many years, the Harmony Park Ballroom was also used for live radio and television broadcasts of country-western and bluegrass shows.

By the summer of 1962, the Retail Clerks Union Hall Auditorium at 8550 Stanton Avenue in Buena Park had started to become another major gathering place in Orange County for teenagers on weekend nights. The building had been around since the 1940s, and it was adjacent to the offices and meeting rooms for the large membership of the United Food and Commercial Workers Union, Local 324. It was the powerful Eddie & the Showmen who brought Retail to prominence and, by the end of the year, had inadvertently established a "rivalry" between Retail and Harmony Park in terms of crowd allegiance. Fans of Dick Dale & the Del-Tones went to Harmony Park; fans of Eddie & the Showmen went to Retail. The two venues were only four miles apart.

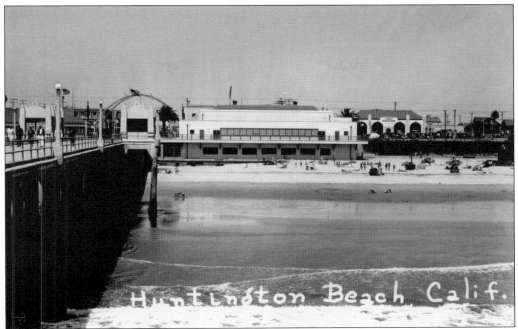

A few miles up the coast from the Rendezvous, the Pavalon Ballroom in Huntington Beach, at 317 Pacific Coast Highway, was another important venue in the early history of surf music in Southern California. It was built by the Works Progress Administration (WPA) in 1938 at the foot of the Huntington Beach Pier. In the above photograph, taken in the 1940s, the building directly across Pacific Coast Highway to the right side of the Pavalon will later house the famous Golden Bear nightclub. Below, a 1950s postcard published by Mitock & Sons shows the huge Pavalon Ballroom in relation to the pier and surrounding area. (Above, courtesy of the City of Huntington Beach; below, courtesy of Aaron Jacobs.)

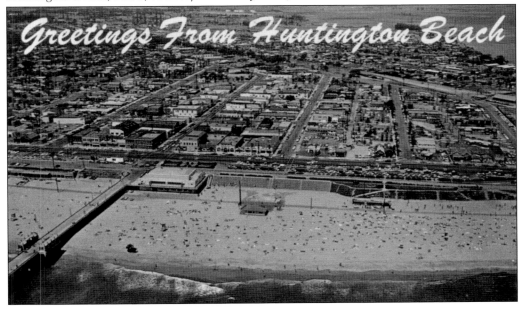

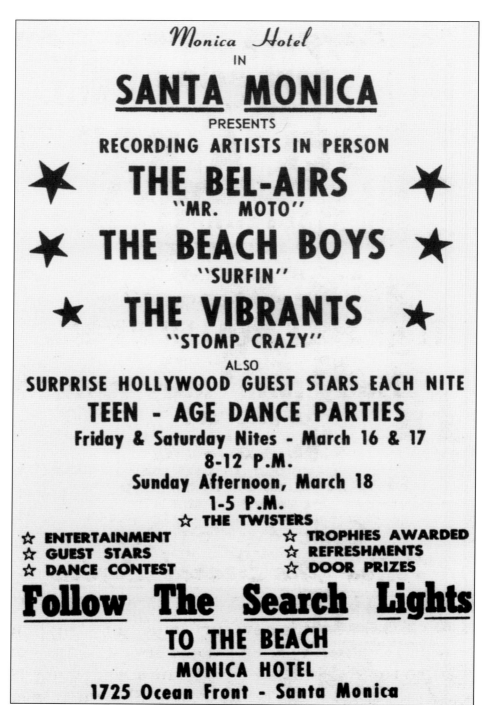

Monica Hotel
IN

SANTA MONICA

PRESENTS

RECORDING ARTISTS IN PERSON

★ **THE BEL-AIRS** ★
"MR. MOTO"

★ **THE BEACH BOYS** ★
"SURFIN"

★ **THE VIBRANTS** ★
"STOMP CRAZY"

ALSO

SURPRISE HOLLYWOOD GUEST STARS EACH NITE

TEEN - AGE DANCE PARTIES

Friday & Saturday Nites - March 16 & 17

8-12 P.M.

Sunday Afternoon, March 18

1-5 P.M.

☆ THE TWISTERS

☆ ENTERTAINMENT ☆ TROPHIES AWARDED
☆ GUEST STARS ☆ REFRESHMENTS
☆ DANCE CONTEST ☆ DOOR PRIZES

Follow The Search Lights

TO THE BEACH

MONICA HOTEL

1725 Ocean Front - Santa Monica

One of the Beach Boys' earliest appearances was at the Santa Monica Hotel on a bill with the Bel-Airs, the Vibrants, and "surprise Hollywood guest stars each nite." At this point in March 1962, the Beach Boys were not even regional stars, so they were given equal billing (not top billing) with the other two main bands.

LET'S **STOMP** ALL NITE

WITH THE

BEACH BOYS

POPULAR RECORDING ARTISTS

'SURFIN' LATEST HIT RECORD

———— NEWEST HIT TO COME

FRI. MAY 4 1962

8 to 12:00 p.m.

INGLEWOOD WOMEN'S CLUB

325 NORTH HILLCREST, INGLEWOOD

TWO LONG BLOCKS EAST OF MARKET ST. AT FLORENCE

FREE SOFT DRINKS FOR THIRSTY STOMPERS

PRINTED by JOHN WILEY'S 14417 S. HAWTHORNE BLVD., LAWNDALE, CALIF.

With only a couple of dozen public performances under their belt, the Beach Boys appeared at the Inglewood Women's Club on May 4, 1962, two weeks after recording "Surfin' Safari" (the "newest hit to come," as noted on the poster) and a month away from that record reaching the Top 20 on the *Billboard* charts. Note the enticing "Free soft drinks for thirsty stompers." The Stomp was a new dance craze born at the Rendezvous Ballroom. Many of the surf bands soon played for "stomps" rather than "dances."

The Stomp—or the "Surfer's Stomp," as it was also called—was perhaps more popular on Southern California dance floors. An advertisement for a Dick Dale appearance at the Swing Auditorium in San Bernardino on February 21, 1962, shouted "THE BIGGEST STOMP EVER!"

Three

THE POPULARITY OF SURF MUSIC EXPLODES

For most of 1962 in Southern California, surf music was pretty much corralled within the coastal communities of Orange County and Los Angeles County. More bands started to appear, inspired by the "Dick Dale sound," the sound of surf music. It was not long before instrumental surf bands started to show up farther inland, thanks, in part, to Dick Dale & the Del-Tones, as well as the Bel-Airs, who took their music into neighboring Riverside and San Bernardino Counties.

Surf bands played mostly guitar-driven instrumentals. Vocals were almost second thoughts; they were frequently simple three-chord rhythm and blues or rock 'n' roll cover songs. Regardless, it was all intended for dancing.

Vocal surf groups, however, such as the Beach Boys and Jan & Dean, sang about the emerging Southern California coastal lifestyle. Dick Dale has said that "they were surfing songs [with] surfing lyrics. In other words, the music wasn't surfing music. The words made them surfing songs. . . . That was the difference . . . the real surfing music is instrumental."

The vocal surf groups were slow to catch on locally, but they did quite well nationally. Since most of the vocal surf groups recorded for major record labels, their recordings achieved a wide geographic exposure, which allowed the local experience to be vicariously shared by people in other areas of the country and overseas. It was easier to identify with cars, girls, and an endless summer of fun by listening to vocal songs about these subjects rather than to instrumentals. Local scenes developed that were well defined in some cases, although not as integrated as in California.

In July 1962, the Beach Boys signed a seven-year contract with Capitol Records, "Miserlou" by Dick Dale & the Del-Tones was released on a single in September, and the first albums by the Challengers and the Beach Boys were released in October. In December, the Chantays' "Pipeline" hit the airwaves; Fender Instruments introduced its most powerful guitar amplifier, the Dual Showman (developed by Leo Fender in tandem with Dick Dale); and the Surfaris recorded the iconic "Wipe Out" at a small studio in Cucamonga, an hour's drive from the nearest beach.

The stage was set for 1963, the year that surf music appeared on the radar of teenagers from coast to coast. In March, *Variety* magazine reported that "A new musical fad is sailing in from the Coast. It's called 'surfing music' and it's expected to take hold of the teenage market on a national scale within the next few months . . . its followers are just teenagers who've exchanged the hot rod for the surf board. Some surfers say that surfing has become 'a way of life' and the surf sound is a way for them to identify with music."

Also in March, *Music Vendor* magazine winked, "Boarding should certainly keep the record industry from being bored for the next few months." Regardless of the proximity to an ocean or a beach, by year's end, it is safe to say that surf music was being recorded and performed by bands in every state in the union.

In August, *Life* magazine ran a two-page spread on Dick Dale, headlined "The Good Life of an Idol." The article noted that "the 12 to 20 set . . . swarm to hear him wherever he plays, buy up his record albums and have lifted him into the $100,000-a-year bracket."

Fender Musical Instruments experienced an increase in guitar sales in 1963. It would be the year that "Surfin' USA" and "Surfer Girl" became national Top 10 hits for the Beach Boys, the Chantays' "Pipeline" went to No. 4 nationally, and the band appeared on the *Lawrence Welk* television show. Jan & Dean scored a No. 1 national hit with "Surf City," and the Surfaris placed three surf instrumentals in the Top 100 ("Wipe Out," "Surfer Joe," and "Point Panic"). Surf music artists (particularly the Challengers and Dick Dale) were frequently seen on Southern California television programs. One of the most popular after-school dance programs each weekday was the *Lloyd Thaxton Show*. Dick Dale appeared on the nationally televised *Ed Sullivan Show* on October 6, 1963. The movie *Beach Party*, starring Annette Funicello and Frankie Avalon, was released in July, starting the "beach party" film genre that included over a half dozen "fun in the sun" movies over the next several years.

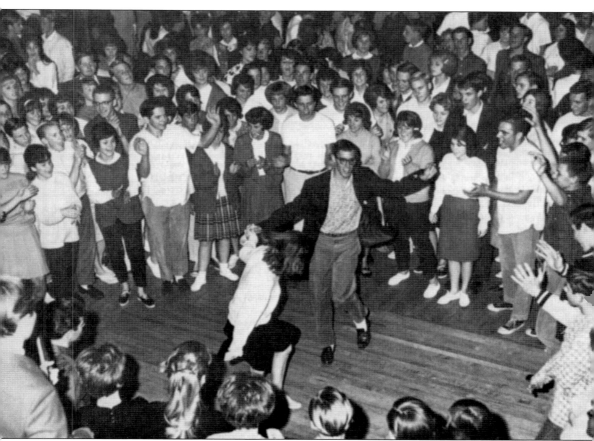

Dancing was the main activity whenever a surf band fired up its amplifiers. It was the primary social activity for teenagers at that time. Here, an audience gathers around a couple at the Rendezvous Ballroom as they tear up the dance floor. The Twist was arguably the most popular dance; it was the first major one, in fact, in which the couple did not have to touch one another. On the East Coast, the dance craze was the Peppermint Twist (Joey Dee's recording with the same title was a No. 1 record in January 1962). But, at the Rendezvous, everyone was doing the Surfer's Stomp.

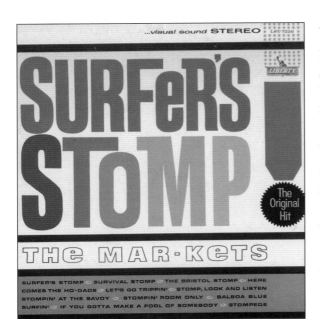

The first record to appear on the *Billboard* Top 100 chart that had any indication of the forthcoming wave of surf music was "Surfer's Stomp" by the Mar-Kets in late January 1962. Although inspired by the dance that began at the Rendezvous Ballroom in 1961, the record did not sound at all like Dick Dale & the Del-Tones, Bel-Airs, Challengers, Surfaris, Chantays, or any of the handful of guitar instrumental bands playing in Southern California. Yet, it was a modest national hit, peaking in the Top 40 by the end of February. It was considered more of a dance record than a surf record, although it did portend the use of the word "stomp," which became synonymous with "dance." Very soon, everyone would be going to surf stomps, not surf dances.

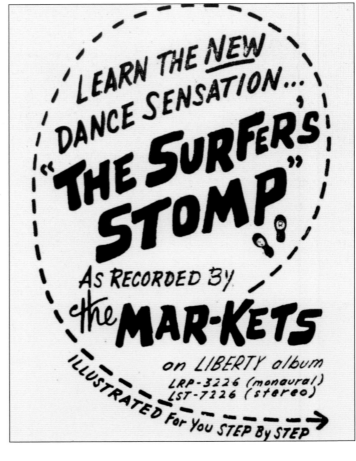

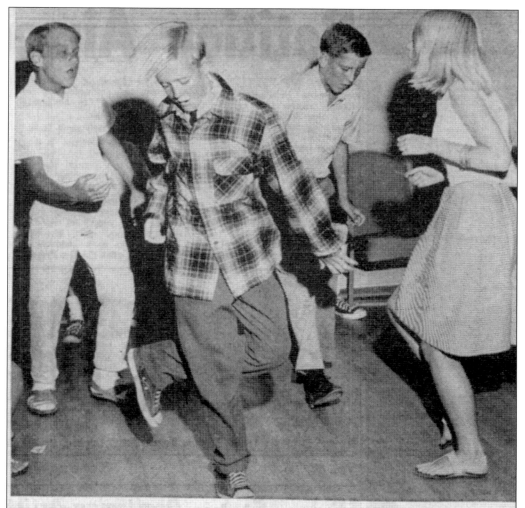

WHO NEEDS A PARTNER?—Laguna youngsters do the Surfers' Stomp—obviously a varia tion on the twist—at Rotary-sponsored youth dance held in the Art Colony Friday night during the school year. Among hundreds of teeners who live it up at the dances are (fron left) Kim Gibian, Bo Swartout, Bill Stewart and Toni Francis.

This article from the July 30, 1963, edition of the *South Coast News* (Laguna Beach, California) captures the Surfer's Stomp in action. The dance originated at the Rendezvous Ballroom in 1961. Note the huarache sandals and Pendleton shirt worn by Kim Gibian (far left) and Bo Swartout (second from left), respectively. This was typical street wear of surfers (and wannabe surfers) at the time. (Courtesy of Orange County Archives.)

♯♭♮ Here it is - "The Surfer's Stomp" ♯♭♮

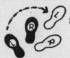
STEP #1: Clasp hands behind your back. With feet slightly apart, stomp twice with right foot.

STEP #2: Right foot pivots right, left foot comes around front and stomps twice.

STEP #3: Left foot pivots left, right foot comes around front and stomps twice.

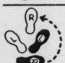
STEP #4: Right foot pivots right, left foot comes around front and stomps twice.

STEP #5: Left foot pivots left, right foot comes around front and stomps twice.

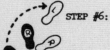
STEP #6: Right foot pivots right, left foot comes around front and stomps twice.

STEP #7: Right foot steps back, left foot moves over left and stomps twice.

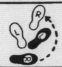
STEP #8: Left foot pivots left, right foot comes around front and stomps twice.

STEP #9: Right foot pivots right, left foot comes around front and stomps twice.

STEP #10: Left foot pivots left, right foot comes around front and makes three quick short stomps.

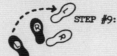
STEP #11: Right foot pivots right, left foot comes around front and stomps twice.

Now begin again with Step #1 and try it while you shimmy your shoulders.

(*SOLID BLACK SHOES ARE STARTING POSITION)

It was thoughtful of the Mar-Kets to include a flyer inside their first album with step-by-step (pun intended) instructions on how to do the Surfer's Stomp. The dance was created by the Rendezvous Ballroom audiences in 1961 that came to hear Dick Dale & the Del-Tones. As a tip of the hat to the dance, Dale recorded an instrumental called "Shake 'n' Stomp" in early 1962.

Students Stomp at Noon Dance

Absence was salvation and an off-campus permit a ticket to peace and quiet November 1 when Harbor High students participated with foot-sore and open-mouthed appreciation in an odd cultural phenomenon of our time —the noon dance.

Two guitars, a piano, a bass, and drums were manned by an all-Harbor group who cleverly go by the name of Nomads, the allegorical meaning of which should be obvious'. . . shouldn't it?

Though blatantly ritualistic, the dances in which the frenzied students participated were of folk origin, such as the Rendezvous (or Surfer) Stomp, a time-worn chantey of the brave men and boys who go down to the sea on boards.

Whether a quaint folk dance or a complicated ritual for the introduction of two complete strangers, the Stomp, to which the dance's name has been lovingly abbreviated, more than proved its ambiguity. Frequently a dancer would begin on one side of the room with his original partner, and end on the other side of the room with an entirely new partner, presumably someone else's.

Such situations did prove embarrassing, of course, especially when — in moments of confusion — boys were seen dancing with boys and girls with girls. Such arrangements invariably proved unsatisfactory, however, and were quickly broken up as soon as participating persons realized their error.

So confusing were these mix-ups that it is only a matter of time until the Stomp is encouraged by all those who are constantly trying to think of feasible ways of discouraging steady dating among teenagers.

Yet, no matter what one may say of the participants in that modern day danse macabre, the greatest pity is that most of the persons at the dance didn't dance at all, preferring to stay on the sidelines and watch — particularly the faculty!

This administrative contingent seemed to have no interest in the Stomp, but were lost in nostalgia for the dances of their day: the Black Bottom, the Lindy, the Charleston, and of course, the Big Apple.

The Newport Harbor High School student newspaper, the *Beacon*, reported on a noon dance, an "odd cultural phenomenon of our time," featuring the surf band the Nomads. The droll "Students Stomp at Noon Dance" article appeared in the November 15, 1961, issue of the newspaper. (Courtesy of Costa Mesa Historical Society.)

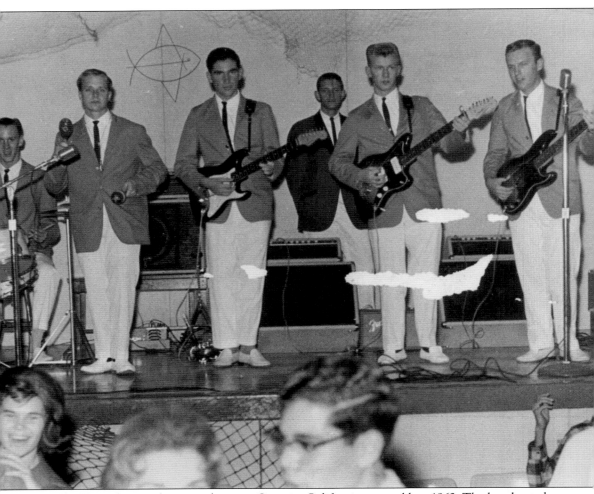

The Tornadoes perform at a dance in Ontario, California, around late 1962. The band members look very collegiate in matching clothes, all the way down to the white loafers. Hailing from Redlands, just east of San Bernardino, the group formed in 1960 and became one of the most popular dance bands in the area. Their first record, "Bustin' Surfboards," was released in the early summer of 1962. Shown here are, from left to right, Leonard Delaney, George White, Roly Sanders, Dave Aerni (the band's manager), Jesse Sanders, and Gerald Sanders. (Courtesy of Gerald Sanders.)

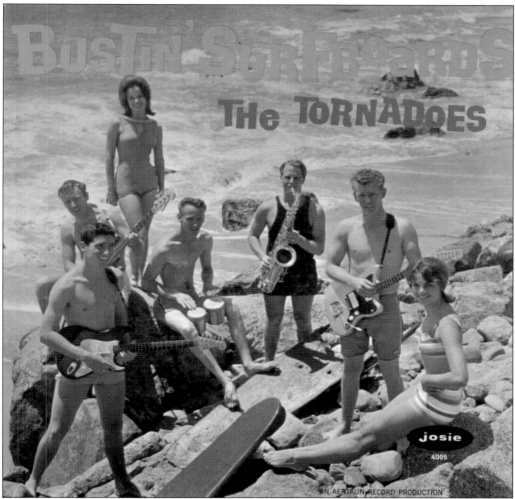

The Tornadoes' first and only album was released in July 1963. All of the tracks were instrumental, except for three somewhat unusual choices for vocal covers: "Summertime," "Old Shep," and "Johnny B. Goode"—a George Gershwin composition for the opera *Porgy and Bess*; the Red Foley song about a boy and his dog popularized by Elvis Presley; and the Chuck Berry rock 'n' roll staple, respectively.

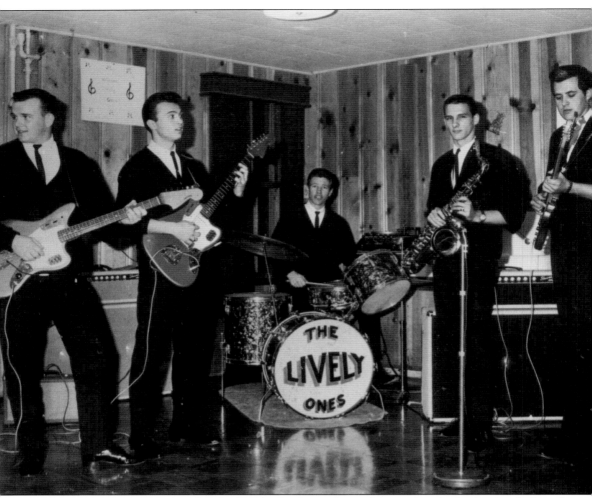

In 1962, an Orange County band called the Expressos changed its name to the Surfmen and released several excellent surf instrumental recordings before replacing some members and changing its name again. This time, apparently due to a comment from KFWB disc jockey Gene Weed about how lively the band was on stage, the new name became the Lively Ones. With help from Weed, they signed with Del-Fi Records and became one of the more well-known and respected surf bands of the era. The Lively Ones were one of the few surf bands to tour and perform outside of Orange County, including forays into northern California and Las Vegas. Shown here are, from left to right, Jim Masoner, Ed Chiaverini, Tim Fitzpatrick, Joel Willenbring, and Ron Griffith.

PAVALON BALLROOM
HUNTINGTON BEACH

THURS. NITE - JUNE 20th. 8:00p.m.
 to
IN PERSON... 12:00p.m.

DEL-FI RECORDING BAND

THE
"LIVELY ONES"
"SURF RIDER" - Album - "SURF DRUM"

"SINGLE RELEASE"

"HIGH TIDE"

SPECIAL ATTRACTION **JULY 3 - 4 & 6th**

This Lively Ones' Pavalon Ballroom appearance took place over the Fourth of July weekend in 1963. They had recorded their signature instrumental, "Surf Rider," earlier that year. (The song would later be used as the closing theme for Quentin Tarantino's 1994 film *Pulp Fiction*.) By the time of the appearance advertised here, the band had already released five singles and two albums, *Surf Rider* and *Surf Drums*.

New Beach Board Music From Cal: No Surf-ace Craze To Diskeries

California, the land of fruits and fads, is sending forth its latest craze: surfing music, and experts believe it is gaining surf-ficient momentum to make a strong dent in teens, to say nothing of their market.

Indie firms on the West Coast have been oozing countless singles and LPs inspired by the sea sprites and their aquatic antics, with majors now expected to follow Capitol Records' new lead in acquiring and nationally promoting Dick Dale—who has the album, "Surfers' Choice."

Last year Cap got started with the surf sound via The Beach Boys and their 45er and LP, "Surfin' Safari." And it is now prepping another Beach Boys LPackage, "Surfin' U.S.A."

According to those in the know, surf music is little more than rock 'n' roll with all accompanying factors revolving around the surfing motif, its exponents merely teens who have exchanged the hot rod for the surf board. White levis and parkas are the official garb.

Surf music, apparently headquartered at California's Balboa Beach, is reported to have started in Hawaii, is next expected to strike big in Florida from where it should move up the East Coast as the weather gets warmer.

Other major diskeries about to brave the briny include RCA Victor, with a tune called "Bonzai Pipe Line" in a new Henry Mancini LP, "Uniquely Mancini"; Dot's just plain "Pipeline," the single by the Chantays; Decca, with "The Birds," by the Surf Riders; and the Dolton LP, "Surfing" by the Ventures. Epic is also planning a plunge.

Nevertheless, the Coast still has a big edge on the new fad. Capitol had to buy Dick Dale from Deltone, a label still big on the surf sound. The Bob Keene-headed diskery has four surfy albums on tap: "Surf Rider," by The Lively Ones; "Surfers' Pajama Party," by Bruce Johnston; "Wipe Out," by the Impacts; "Big Surf," by The Sentinels, and "Battle of The Surfing Drums," the latest set featuring 12 different surfing groups. The Lively Ones also have a new one for immediate release and Keene also has four more albums on the matter due this month.

Also Coasting along are Vault Records with "Lloyd Thaxton Goes Surfing With The Challengers" and "Surf Beat," by The Challengers; plus "Surf Crazy," by Bob Vaught and The Renegades on Crescendo.

Boarding should certainly keep the record industry from being bored for the next few months.

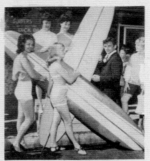

Dick Dale

Dale Promo Films

HOLLYWOOD — Two motion picture cameras recorded the sights and sounds of a typical Friday night at the Harmony Park Ballroom when Dick Dale and his Del-Tones play there.

Capitol will have two audio 16mm. black-and-white movies in nation-wide distribution within three weeks. The filming, handled by Watson-De'Atley Productions under the direction of Capitol's Fred Rice, took place March 22 at the Anaheim ballroom. One of the films is a three-minute spot featuring Dale's performance of his current single release, "Miserlou," with a visual demonstration of the Stomp. (The Stomp is the dance which originated among Dick's fans at the Harmony Park and other southern California ballrooms.) The second movie runs 13 minutes and includes on-the-spot performances of "Miserlou," "Surfin' Drums," "Greenback Dollar" and other numbers.

Both films are available to disk jockeys for television shows and record hops coast-to-coast.

In the early 1960s, there were at least five weekly music trade publications. The big two were *Billboard* and *Cashbox*, but there also were *Music Business*, *Music Reporter*, and *Music Vendor*. As the surf music trend grew in Southern California, the trades began to take notice. The March 30, 1963, issue of *Music Vendor* was one of the first to validate how popular the music was in Southern California, announcing the pending spread of the music across the country. Regarding the article "Dale Promo Films," Capitol Records did film a Dick Dale performance at the Harmony Park Ballroom on March 22 of that year, but the film did not result in wide distribution to disk jockeys, television shows, or record hops, as the article indicates. However, copies of the footage can be seen today on the Internet as one of the very few live performances of an early surf band captured on film.

Surfing Craze Ready to Splash Across Country to East's Youth

By LEE ZHITO

HOLLYWOOD—When California's surfing craze spills across the nation—and many here claim it's about to happen—the U. S. will find itself ear-deep in the kookiest, wildest, and most refreshing fad within memory.

The surfing storm has been brewing long on California's beaches. It has already engulfed Hawaii and Australia, and is reaching into Japan. During this time, it has armed itself well for a long siege of the land-locked points beyond the Great Divide.

Its disciples list the following factors in favor of surfing conquering the country at large:

It's a fad that belongs to the teen-and-20 set, an age group most inclined to ardently follow the unorthodox.

Surfing is a sport that connotes courage, and as such, has become a status symbol among youngsters who strive to be linked or "in" with anything that is related to surfing. Furthermore, surfing requires an investment of more than $100, and sometimes closer to $200, thereby adding to the status appeal. Those who can't afford the gear can be part of the crowd through the music and dance.

Fun and Games

For the first time, a sport has emerged with its own music, and its own dance step, thereby combining the appeals of all three. Those who can't surf, can be part of the group by digging the music or becoming proficient in dancing it.

The fad (i.e. sport-music-dance) has developed its own uniform which readily identifies the surfer—hair bleached blond (to give one the sun-faded look), and white levis cut off at the knee. Many can be seen sporting this attire whose sole acquaintance with a body of water is

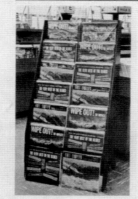

MUSIC CITY in Hollywood features a "surfing rock" which displays many of Del-Fi's surfing LP's, hint of importance of surf craze in sunny Southern California.

the family bathtub. It has developed its own lingo.

Surfing has become big business to countless suppliers who manufacture everything from records and surf boards to swimming gear and apparel. They are eager to keep the fad alive, and continue to fan its flame with new products and promotion to see that it spreads.

The fad has shown its strength by spilling over into other fields, including records, in addition to music and dancing, its unique form of transportation—the old panel station wagon or "woodie,"

or the most coveted form of transporting gear, the used hearse. Time was when nothing was quite as dead on the used car market as last year's hearse. Today, the used hearse is one of the rarest items as a result of the great demand created by surfers.

Until recently, this phenomenon existed only in the Southern California beach cities. Now, it has spread into the desert communities of Arizona where the sight of a "woodie" or a "surfin' hearse" is not uncommon. Members of the arid wing of the surfing clan may get to drive to the California coast but once a year, but when they do arrive, they do so in style.

The fad today has at least three periodicals in Southern California to foster its growth. Surfer Magazine is four years old and claims to be the strongest, with a circulation of more than 70,000. Its general manager, Dale Cole, told Billboard that its distribution includes approximately 10 per cent to readers abroad, and embraces many countries, including such land-locked areas as Switzerland. Its haviest foreign readership is in Australia, Union of South Africa, Peru, Japan and England. It also boasts ardent readers among many of the land-locked cities of the U.S., though the lion's share of its readers are on the West Coast.

In addition to the above list of strong points in favor of the surfing trend's spread into oceanless areas are the reports by the various record companies that their surf disks are taking hold in land-locked markets. Similarly, performers of surfing music have enjoyed strong turnouts where the closest body of of water is a creek.

On page one, above the masthead of the June 29, 1963, issue of *Billboard* magazine, was the headline, "Surf Music Splashes Way Across U.S." Inside the issue was a full page of news stories about the "craze" that was new to the rest of the country but not to Southern California. "What is 'surfing music'?" was the question one article posed to Murray Wilson, manager of the Beach Boys (and father to the band's Brian, Carl, and Dennis Wilson). He responded as follows: "The basis of surfing music is a rock and roll bass beat figuration, coupled with a raunchy-type weird-sounding lead guitar. . . . Surfing music has to sound untrained with a certain rough flavor to appeal to the teenagers." Another article, shown here, portends the spread of the music across the country, although couched as an "unorthodox fad." By mid-1963, surf music had already spread east of the Rockies and was building in radio airplay and in the number of recordings coming out of independent studios in the Midwest and East. The summer of 1963 represented the peak of surf music's popularity with the country's teenagers, coast to coast.

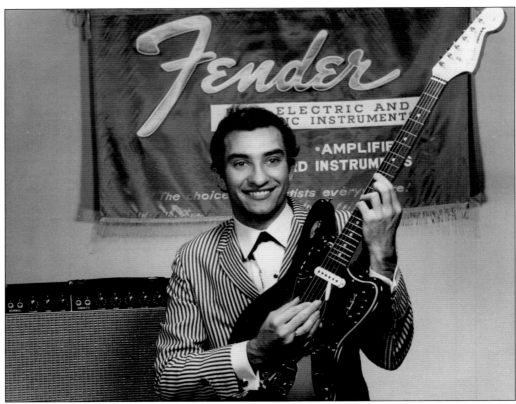

Johnny Fortune (his real name was John Sudetta) came to California from Ohio in 1959 and started playing guitar at the age of 12. He patterned his playing style after Chet Atkins, so he was not a surf guitar player in the same sense as Dick Dale. Fortune lived in Ontario, California, and recorded his most well-known tune, "Soul Surfer," at the Sound House Studio in nearby El Monte. Although the single did not do well nationally, it received solid airplay on Southern California radio stations, resulting in his only album release in October 1963. Fortune also worked as a session guitarist, playing on Sam Cooke's "Chain Gang" (1960) and on Barbara George's "I Know" (1961).

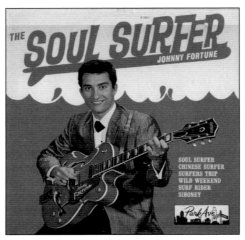

The FABULOUS
JOHNNY FORTUNE
and his band

Friday Nite
July 26, 1963
Riverside Armory

ALSO

The **Nomads**

Playing their smashback hit "Take It Off"

Listen to KMEN for details

Located in Riverside's Fairmount Park, the California National Guard Armory, built in 1960, was the site of many surf band dances. There was plenty of parking, easy freeway access, and lots of room for 200 to 300 kids to stomp the night away. Besides a showcase for local Riverside and San Bernardino bands (such as the Nomads), it was also the place to hear local radio favorites such as Johnny Fortune and the Tornadoes. San Bernardino radio station KMEN (the first to play Dick Dale's "Let's Go Trippin'" and "Miserlou") often sponsored dances there.

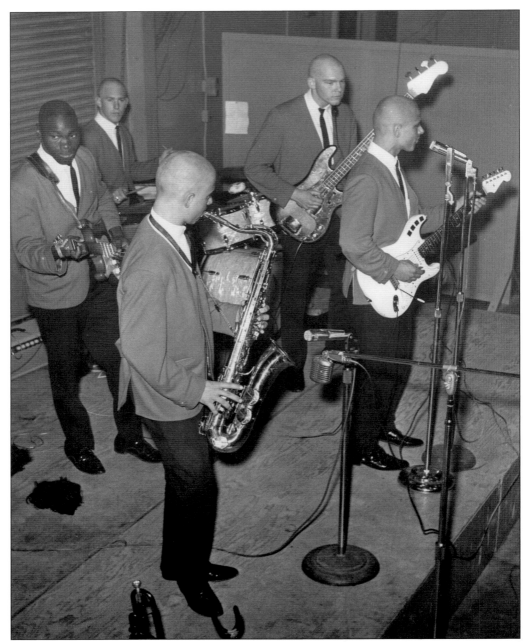

The Pyramids were a five-piece surf band from Long Beach known for their hit surf instrumental "Penetration." The record's success led them to appear on several television dance programs, such as the *Lloyd Thaxton Show, American Bandstand, Shebang,* and *Hullabaloo.* They were one of the few surf bands to appear in a theatrical motion picture, the 1964 film *Bikini Beach,* starring Annette Funicello and Frankie Avalon. Here, the band performs at the California National Guard Armory in Riverside. The band members are, from left to right, Will Glover, Ron McMullen, Tom Pitman, Steve Leonard, and Skip Mercier. Note the Beatles wigs on the floor. As a gimmick, the band members would shake them off at the start of a show to reveal shaved heads.

The single "Penetration" became a national hit, reaching No. 18 on the *Billboard* Top 100 chart in November 1963. Unlike most surf bands at the time, the Pyramids used gimmicks (other than their bald heads) to help attract attention. They arrived at one show in a helicopter, at another riding elephants! The band's lead guitarist, Skip Mercier, was known for doing backflips off the stage. The Pyramids were also one of the few surf bands that continued recording and making personal appearances after the rise of the Beatles in 1964. (Poster courtesy of Bob Dalley.)

The June 29, 1963, issue of *Billboard* magazine was rife with articles and advertisements extolling the new sound of surf music. This was akin to Paul Revere's famous ride on that April night in 1775 warning that the British were approaching Lexington, Massachusetts. Surf music was about to break nationwide. Del-Fi Records, owned by Bob Keene, was one of the major independent labels to release surf music. Over a dozen surf albums, and an equal number of singles, were released by Del-Fi in 1963. The label experienced great success with the Lively Ones (from Southern California) and the Sentinals (from central California).

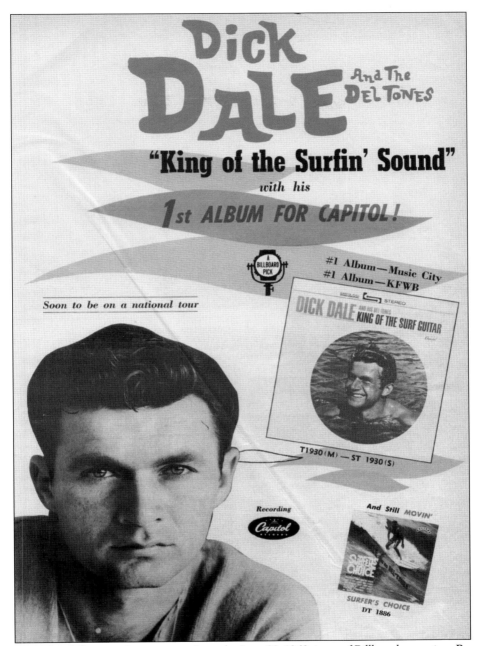

This is another full-page advertisement from the June 29, 1963, issue of *Billboard* magazine. Because of Dick Dale's immense popularity—as evidenced by his performances at the Rendezvous and Harmony Park Ballrooms in 1961 and 1962 and the strong sales of his first, independently released album, *Surfer's Choice*—it was no surprise that he was courted by several major record companies. Label signings typically did not result in much fanfare from trade magazines, but page one of *Billboard*'s February 23, 1963, issue was headlined "Capitol Snags Dick Dale After Hot Bidding." The label immediately rereleased Dale's first album and rushed him into the studio to record his second album, *King of the Surf Guitar*.

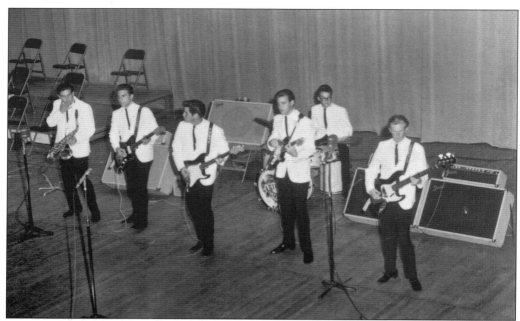

By the summer of 1963, hundreds of teenage surf bands in Southern California were plying their trade from San Diego to Santa Barbara. One of the better and more popular bands was Eddie & the Showmen, a group from Palos Verdes, which signed with Liberty Records in early 1963. The band is shown on stage in these 1965 photographs. Above, the members are, from left to right, Bob Knight, Larry Carlton, Eddie Bertrand, Rob Edwards, Mike Mills, and Doug Hensen. Shown in the photograph below are, from left to right, Knight, Bertrand, Carlton, Mills, Edwards, and Hensen. Today, Larry Carlton is known as one of the country's top jazz guitarists. He has won four Grammy awards for his performances and compositions. (Above, courtesy of Randy Nauert; below, courtesy of Kathy Marshall.)

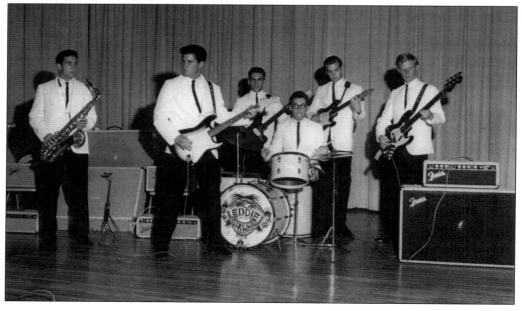

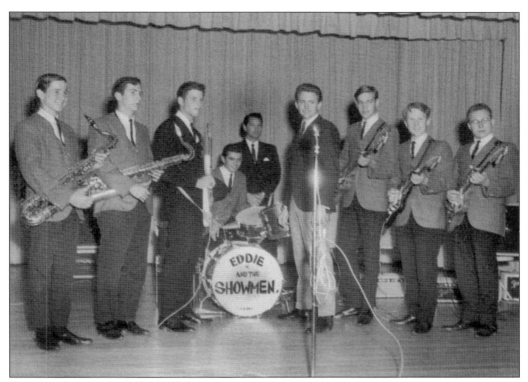

For several years, the Bel Air Club in Redondo Beach was the focal point of the South Bay music scene. When it was bought by KRLA disc jockey Reb Foster in early 1963, it was renamed the Revelaire Club. Eddie & the Showmen played there almost exclusively until the summer of that year, when they were hired by Foster as the house band for the dances he was promoting at the Retail Clerks Union Hall Auditorium in Buena Park, 25 miles due east from Redondo Beach. Shown above is the band's 1963 lineup. Posing on stage are, from left to right, Sterling Storm, Bob Knight, Eddie Bertrand, Dick Dodd (who later went on to join the hit band the Standells), Bert Bertrand (the band's manager), Reb Foster, Rob Edwards, Fred Buxton, and John Anderson. The handbill shown at right is from December 1964. (Both, courtesy of Kathy Marshall.)

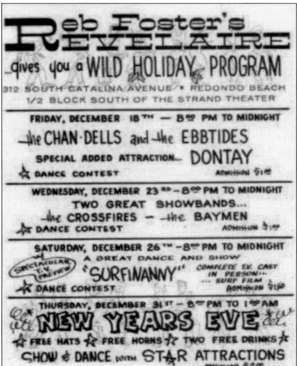

Reb Foster's REVELAIRE
gives you a WILD HOLIDAY PROGRAM
312 SOUTH CATALINA AVENUE • REDONDO BEACH
1/2 BLOCK SOUTH OF THE STRAND THEATER

FRIDAY, DECEMBER 18TH — 8:00 PM TO MIDNIGHT
the CHAN-DELLS and the EBBTIDES
SPECIAL ADDED ATTRACTION... DONTAY
☆ DANCE CONTEST ADMISSION $1.00

WEDNESDAY, DECEMBER 23RD — 8:00 PM TO MIDNIGHT
TWO GREAT SHOWBANDS...
the CROSSFIRES — the BAYMEN
☆ DANCE CONTEST ADMISSION $1.00

SATURDAY, DECEMBER 26TH — 8:00 PM TO MIDNIGHT
A GREAT DANCE AND SHOW
SPECTACULAR T.V. PREVIEW "SURFINANNY" COMPLETE T.V. CAST IN PERSON — SURF FILM
☆ DANCE CONTEST ADMISSION $1.50

THURSDAY, DECEMBER 31ST — 8:00 PM TO 1:00 AM
NEW YEARS EVE
☆ FREE HATS ☆ FREE HORNS ☆ TWO FREE DRINKS ☆
SHOW & DANCE with STAR ATTRACTIONS
ADMISSION $2.00

A vast number of surfing movies were produced in the late 1950s and well into the 1960s. The independent, 16-millimeter silent films were shown in small movie theaters, high school auditoriums, and various public meeting halls up and down the California coast. They would typically be narrated by the filmmaker, with a tape or record album of instrumental music playing in the background to help set the mood. This actually helped to establish the association of instrumental guitar music with the sport of surfing in 1961. It was no surprise, then, to see surfing movies shown as part of a surf music stage show by 1963. (Courtesy of Kathy Marshall.)

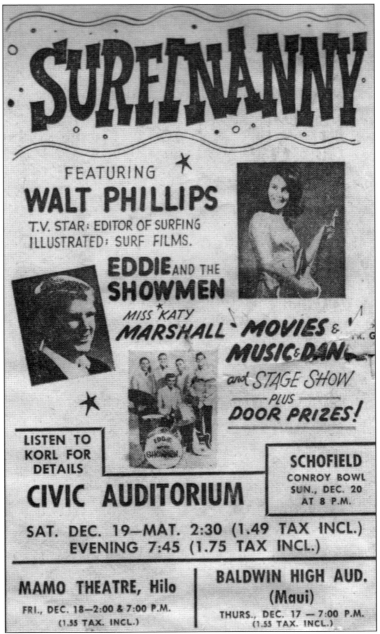

Walt Phillips was a filmmaker who made a number of surfing movies, including *Sunset Surf Craze* (1959), *Surf Mania* (1960), and *The Waves* (1964). For a short time, he was the host of a weekly Los Angeles television program called *Surf's Up*, which debuted in June 1964. The program featured scenes from current surfing movies, in-studio interviews with surfing celebrities, news about surfing events, and music from a local surf band. That winter, Phillips organized a tour of Hawaii that combined his narration of surfing film footage with the talents of Kathy Marshall and Eddie & the Showmen. This was one of the few times that Southern California surf music was taken "on the road." (Courtesy of Kathy Marshall.)

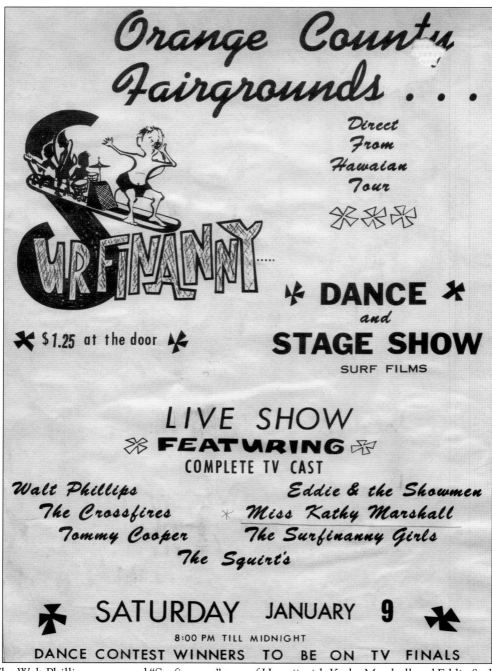

The Walt Phillips–sponsored "Surfinanny" tour of Hawaii with Kathy Marshall and Eddie & the Showmen was so much fun and so successful that he continued the event on the mainland in early 1965. Here, the show comes to the Orange County Fairgrounds in Costa Mesa. KHJ radio disc jockey Stan Richards took over as host of the television program *Surf's Up* in Phillips's absence. A surf band was featured each week during this live program (which continued into 1967), including Dick Dale and, most frequently, the Challengers. (Courtesy of Kathy Marshall.)

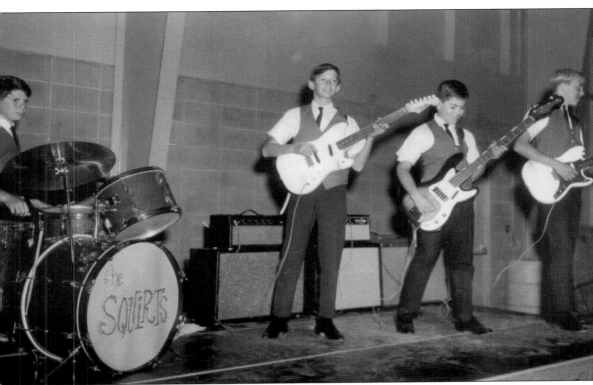

The Squirts perform at the Surfinanny show on January 1, 1965, at the Orange County Fairgrounds. This is the only known public appearance of this rather youthful surf band. It left no recordings behind, and the members' names have been forgotten by time. The age of the band members is interesting, considering that this is from early 1965, well into Beatlemania, when most new bands were not surf bands at all. Also of note, the drummer has set up on stage right, not in the center, as most bands did at that time. (Courtesy of Kathy Marshall.)

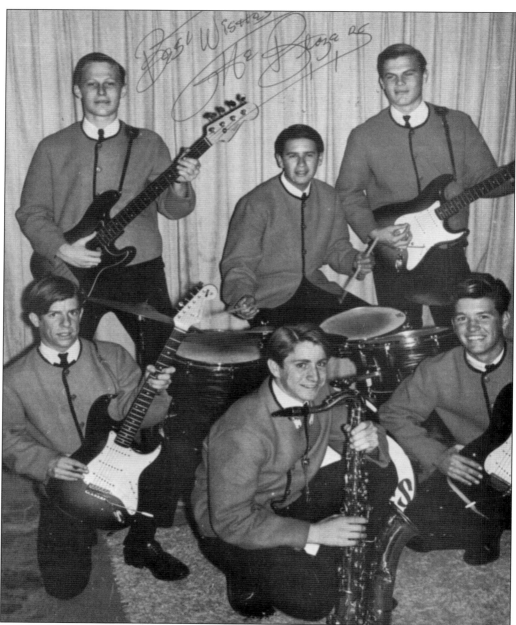

Surf bands typically dressed alike on stage. Matching sport coats and ties were common. In the wake of the Beatles' strong emergence in early 1964, some surf bands adopted a Beatles-type dress code on stage. The Blazers, from Fullerton, was among the first surf bands to take on the collarless style of Nehru jackets that were being worn by the Beatles at that time. The Blazers was the first band to provide backup for Kathy Marshall, at an informal backyard party for her sister's middle-school graduation. Marshall made such an impression that she started appearing with the Blazers on a regular basis, which led to similar guest appearances with other surf bands. Shown here are, clockwise from upper left, John Morris, Chris Holguin, Steve Morris, Wayne Bouchard, Larry Robbins, and Vern Acree Jr. (Courtesy of Kathy Marshall.)

The Blazers recorded two great surf instrumental records, both highly sought after by surf music collectors. The first, from the summer of 1963, was "Shore Break." The second single, "Bangalore," came in February 1964. Both singles were recorded in Downey at the same recording studio used by the Chantays to record the hit "Pipeline." Both records were released on the band's own Acree label. Vern Acree Sr. was the band's manager.

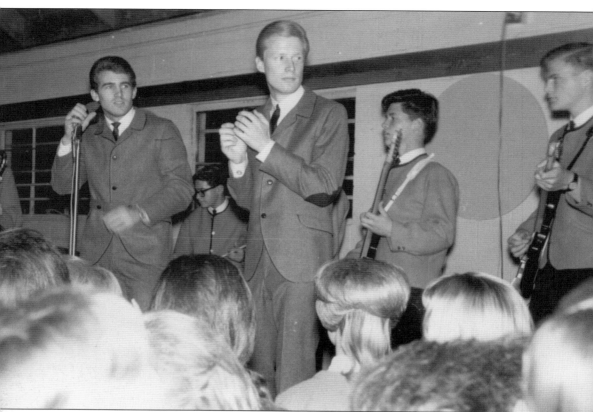

Although the original form of surf music was instrumental, vocal recordings about the surfing experience did more to define the genre outside of California. The Beach Boys and Jan & Dean were the two most prominent vocal artists who took Southern California surf music to the world. Unlike the Beach Boys, who played their own instruments, Jan & Dean needed a backing group whenever they made a personal appearance. It was the same for any duo or single vocalist at the time. In most cases, there was no formal rehearsing. The bands would learn the material beforehand, or even at the venue during breaks. The band would play their typical set and then bring on the night's headliner for a few songs. Here, Jan Berry (left foreground) and Dean Torrence (right foreground) perform at RollerRama, a roller-skating rink in Orange, with the Blazers as the backing band. (Courtesy of Kathy Marshall.)

SURF CITY

b/w SHE'S MY SUMMER GIRL

#55580

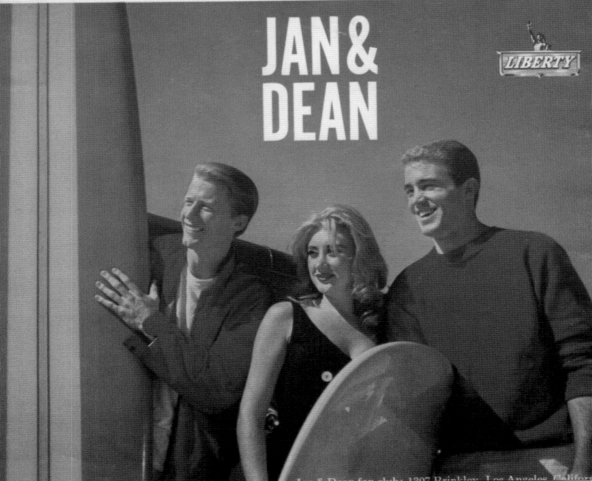

Jan Berry and Dean Torrence met in Los Angeles while in high school in the late 1950s. They had a Top 10 hit in 1959 with "Baby Talk." After a string of hit records through early 1963, they met Brian Wilson of the Beach Boys, who piqued their interest in surf music. Their first No. 1 hit came in June 1963, when they released the anthemic "Surf City" ("Two girls for every boy"), written by Wilson. They continued the theme on subsequent radio hits, such as "Honolulu Lulu," "Ride The Wild Surf," and "Sidewalk Surfin'." By the summer of 1966 (when Jan Berry was seriously injured in an automobile accident), Jan & Dean had garnered 26 charted hit records, 16 of them in the Top 40.

The communities of Redondo Beach, Hermosa Beach, and Manhattan Beach, just to the north of the Palos Verdes Peninsula, make up Southern California's South Bay. This was a fertile area for surf bands, such as the Vibrants (shown here), the Beach Boys, the Bel-Airs, Eddie & the Showmen, the Baymen, Thom Starr & the Galaxies, and the Crossfires. The Vibrants formed when its members were students at Mira Costa High School in Manhattan Beach. They played all over the South Bay for several years and, for a short time, were the house band at the Revelaire Club in Redondo Beach. Shown here are, from left to right, (standing) Jim Tucker, Dick Hoffman, Dave Stadler, and Tony Guidice; (kneeling) Marty Cline and Jerry Sackett.

The second of two singles by the Vibrants was recorded at Gold Star Studios in Hollywood in late 1962. (Note the misspelling of the band's name on the record, shown at right.) "Fuel Injection" reflects a major preoccupation with cars and hot rods among many teenagers. The hot-rod vernacular was as extensive as that of the surf culture. Early Beach Boys singles had a surfing song on one side and a hot-rod song on the other side. The title of an instrumental, of course, is often just a means to an end, but many surf bands certainly went to the canon of hot-rod vernacular for song title inspiration. This would become more prevalent over the next several years among artists such as the Beach Boys, Dick Dale, and Jan & Dean, as "hot-rod songs" became more common than "surfing songs." A 1962 Easter week dance at Newport High School (below) featured several South Bay bands.

Bal-Week Easter Show

COME AS YOU ARE -:- STOMP

Newport High School Stadium

SWING TO THE FABULOUS

BELAIRS

"Mr. Moto" and "Volcanic Action"

SENSATIONAL!

THE BEACHBOYS

"Surfin"

THE VIBRANTS

"Wildfire"

THE FABULOUS BISCAINES
DODIE AND DEE DEE

ONE NITE ONLY!

WED., APRIL 18th

7 P.M. 'TIL?

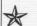

Stomp Every Friday and Saturday Night

BILTMORE BALLROOM

Hermosa Biltmore Hotel

STARRING THE FABULOUS

"VIBRANTS"

TRIUMPH RECORDING STARS

STARTING

NOVEMBER 16th & 17th

...SURFING MOVIES...

Walt Phillips'	J. Perkinson's
"SURF MANIA"	"STANDING ROOM ONLY"

Southern California - Mexico - Hawaii - Santa Cruz

8:00 P. M. TO 12:00 P. M.
DOOR PRIZES...FIRST 10 ADMITTED FREE
RECORDS GIVEN AWAY FREE...SURFIN TEE-SHIRTS FREE
TROPHYS AWARDED

The ballroom at the Biltmore Hotel in Hermosa Beach was used quite frequently by South Bay surf bands for "stomps." Once in awhile, some of these dances/stomps featured surfing movies as part of the evening's entertainment. For these two nights in 1962, the Vibrants brought their music for a performance in between screenings of Walt Phillips's *Surf Mania* and James Perkinson's *Standing Room Only.*

The Esquires hailed from Montclair, California. "Flashin' Red" was the band's only release, a car-themed (in this case, an emergency response vehicle) surf instrumental recorded at the same studio in Cucamonga that produced the Surfaris' "Wipe Out." They briefly toured as Laughing Gravy to promote a release in 1967 by Dean Torrance (of Jan & Dean), who recorded the single under the same assumed name. This was perhaps the only surf band to feature brother and sister twins, Debbie and Durby Wheeler. Aside from her visual appeal on stage, Debbie provided lead and backing vocals, a unique configuration for a surf band at the time. Shown above are, from left to right, Debbie Wheeler, Rick Clingman, Marvin Gillum, Durby Wheeler, and Jim Thompson.

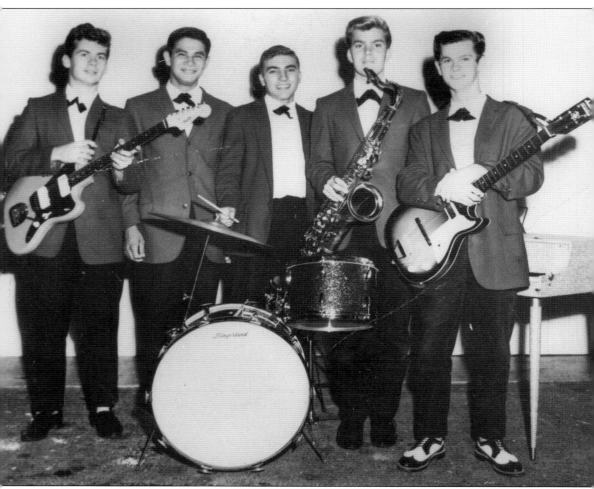

For a short time in late 1962 and early 1963, there were two surf bands called the Surfaris. It was a coincidence that was resolved through a court order. One band was from Glendora (in Los Angeles County), and the other was from Fullerton and La Habra (in Orange County). Once "Wipe Out" started to get serious airplay (eventually becoming a national hit record) by the Glendora Surfaris in early 1963, the other band was forced to change its name to the Original Surfaris. The band played all over Southern California, even venturing north to the San Francisco area on a few occasions, and they recorded several singles as well as tracks on various surf music compilation albums. However, they never achieved the same level of fame as the Glendora Surfaris. The Original Surfaris are, from left to right, Larry Weed, Al Valdez, Mike Biondo, Doug Wiseman, and Bobby Esco.

SURFARI
Records

1312 West Garvey Ave., Monterey Park, Calif.

SIDE I
TIME 2:05

Movin Music
Inc.
B.M.I.
(45-301-A)

GUM DIPPED SLICKS
(Larry C. Weed)
THE ORIGINAL SURFARIS
Larry - Doug - Mike - Jim
& Chuck

By mid-1964, hot-rod music was starting to overtake surf music, not so much in terms of popularity, but in terms of song titles. To stay in vogue with hit vocal records such as "409," "Little Deuce Coupe," "Drag City," "Three Window Coupe," and "Little G.T.O.," a lot of surf instrumentals were given titles using hot-rod vernacular. The Original Surfaris' last single release was such a record. "Gum Dipped Slicks" referred to an obscure racing term for a method of treating the rubber used for treadless racing tires, which provided maximum contact with the track's surface.

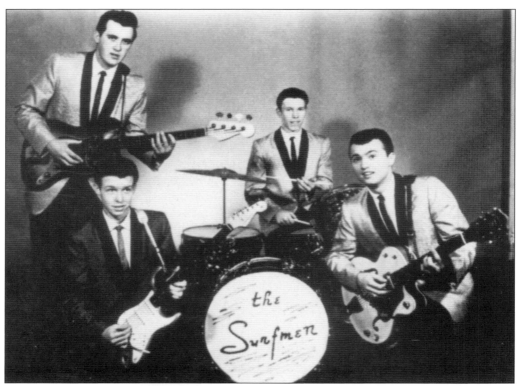

The Surfmen, from Orange County, were previously known as the Expressos. They recorded a tune in 1961 called "Extasy," which was retitled "Paradise Cove" shortly after it was released in January 1962. In late 1962, after replacing a couple of members, the band changed its name to the Lively Ones and became one of the most popular surf bands in Southern California. Posing here are, from left to right, Ron Griffith, Ray Hunt, Tim Fitzpatrick, and Ed Chiaverini.

Redlands, located in Southern California's vast Inland Empire, is just east of San Bernardino. It was the home of the Tornadoes, who had one of the earliest surf instrumental recordings, "Bustin' Surfboards." The Truants, from the same area, never achieved quite the same name recognition. Except for high school gymnasiums or community meeting halls, there were not a lot of places for bands to play at the time, especially in the Inland Empire. The Truants, as with many teen bands, would put on their own dances at rented social halls, the YMCA, or National Guard armories. The band, known as the El Dorados, changed the name to the Truants to match the title of their sole surf instrumental. Shown above are, from left to right, Eddie Rea, Dick Zeiner, Larry Taylor, and Eddie Puchalski.

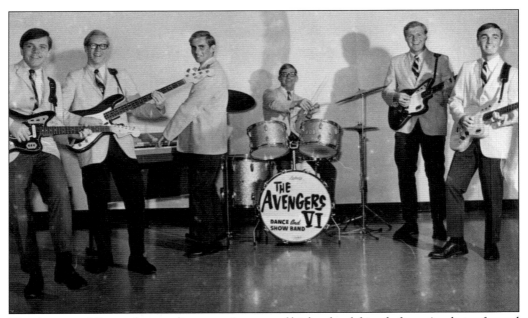

The Avengers VI were late to the party. A group of high school friends from Anaheim formed the band in 1964, when the popularity of surf music in Southern California was waning. At six members, the band had a formidable lineup of three guitars, bass, drums, and keyboards. Some surf bands were fortunate to have released one or two singles. The Avengers VI were luckier; they had a chance to record and release an entire album, the result of a deal a record producer had made with the Good Humor Ice Cream company to create a promotional record. The result was 1966's *Good Humor Presents Real Cool Hits*, a very rare surf music album today. From that album, one single was released, "Time Bomb." Seen above are, from left to right, Jim Fergueson, Curt Pickelle, Mike DeYoung, Bob Gallant, Jim Goodwin, and Rick Bastrup. (Above, courtesy of Rick Bastrup.)

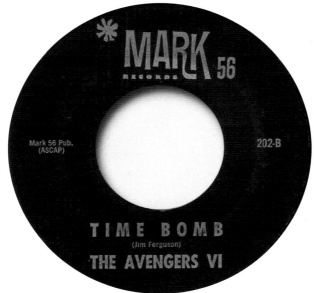

As the popularity of surf music spread inland from word of mouth or radio exposure, surf bands quickly started to appear in nearly every city across Los Angeles and Orange Counties. The Illusions were from Bellflower, about 15 miles from the nearest beach. By the end of 1963, they became the house band at the Lido Ballroom in Long Beach. They were approached one night by a KLFM disc jockey who wanted to record them backing his son, guitarist Marlow Stewart. The result was a surf instrumental called "Earthquake," released in 1964 with a rare picture sleeve (below). Posing in the photograph at right are, from left to right, (first row) Larry Ellis, Randy Ritter, and Bob Mason; (second row) Roy Alvila, Tom Brown, and Colin Clark. (Right, courtesy of Tom Brown.)

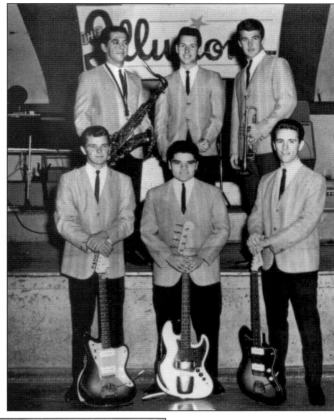

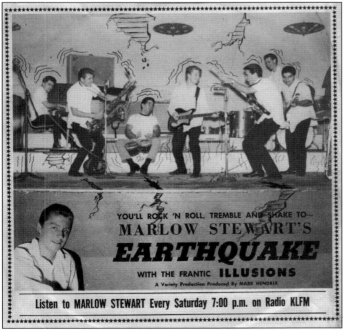

YOU'LL ROCK 'N ROLL, TREMBLE AND SHAKE TO—
MARLOW STEWART'S
EARTHQUAKE
WITH THE FRANTIC ILLUSIONS
A Variety Production Produced By MARK HENDRIX

Listen to MARLOW STEWART Every Saturday 7:00 p.m. on Radio KLFM

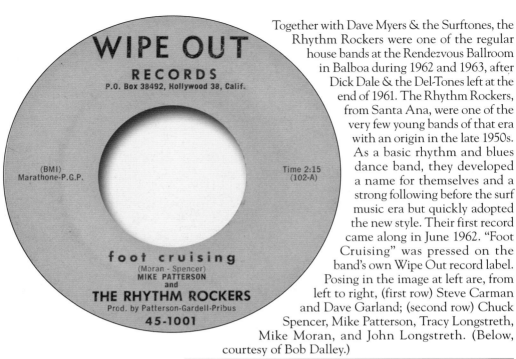

WIPE OUT
RECORDS
P.O. Box 38492, Hollywood 38, Calif.

(BMI)
Marathone-P.G.P.

Time 2:15
(102-A)

foot cruising
(Moran - Spencer)
MIKE PATTERSON
and
THE RHYTHM ROCKERS
Prod. by Patterson-Gardell-Pribus
45-1001

Together with Dave Myers & the Surftones, the Rhythm Rockers were one of the regular house bands at the Rendezvous Ballroom in Balboa during 1962 and 1963, after Dick Dale & the Del-Tones left at the end of 1961. The Rhythm Rockers, from Santa Ana, were one of the very few young bands of that era with an origin in the late 1950s. As a basic rhythm and blues dance band, they developed a name for themselves and a strong following before the surf music era but quickly adopted the new style. Their first record came along in June 1962. "Foot Cruising" was pressed on the band's own Wipe Out record label. Posing in the image at left are, from left to right, (first row) Steve Carman and Dave Garland; (second row) Chuck Spencer, Mike Patterson, Tracy Longstreth, Mike Moran, and John Longstreth. (Below, courtesy of Bob Dalley.)

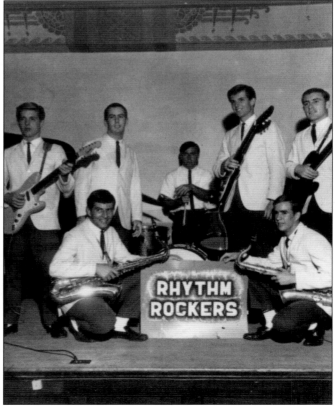

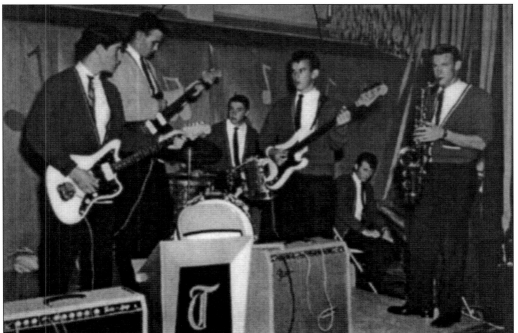

The Cornells were from Los Angeles, with a strong Hollywood pedigree. The band included Bob Linkletter (son of television personality Art Linkletter), Peter Lewis (son of actress Loretta Young and a founding member of the San Francisco rock band Moby Grape in 1966), Jim O'Keefe (son of actor Dennis O'Keefe), and drummer Charlie Correll (son of Charles Correll, who starred in the radio version of *Amos 'n' Andy*). They released a total of four singles and one album on the small Garex label between December 1962 and November 1963. "Beachbound" was their third single from February 1963. Seen above are, from left to right, Lewis, Linkletter, Correll, Tom Crumplar, an unknown keyboardist, and O'Keefe.

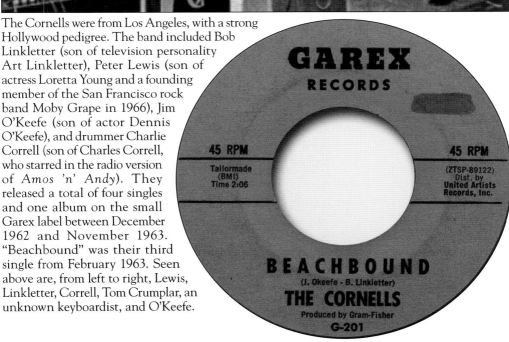

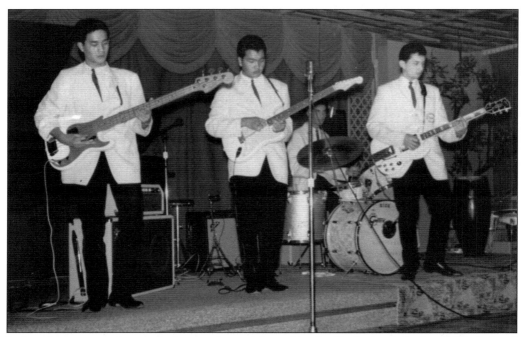

Indorock was a popular musical genre that originated in the Netherlands in the 1950s. It fused Indonesian music with Western rock 'n' roll, having a strong influence on Dutch popular music. Several members of the Rocking Yings, an Indorock band from Holland, emigrated to America around 1961 and settled in Ontario, California. They quickly formed another band, Conrad & the Hurricane Strings (shown above performing at the Bandbox Club in Ontario). They left behind a classic surf instrumental, "Hurricane," recorded at the Pal Recording Studio in Cucamonga and released in the winter of 1963. This was an early Frank Zappa production (using the pseudonym Curry). He had worked at Pal since late 1961 and bought the studio from owner Paul Buff in 1964. The band members shown above are, from left to right, Don Sigarlaki, Ed Sigarlaki, Pat Couwenberg, and Conrad Couwenberg.

The Chevells formed in Anaheim in late 1961 and started playing for school and teen center dances in the summer of 1962. As with many surf bands, the desire to better promote themselves brought them into a recording studio in the summer of 1963. The result was a 45 rpm record featuring the surf instrumental "Let There Be Surf." It was cut at the Downey Recording Studio, where the Chantays' "Pipeline" had been recorded six months earlier. The Chevells received some modest airplay on a couple of Southern California radio stations but not enough to elevate the band's popularity beyond Orange County. Shown above are, from left to right, John Walsh, Don Snow, Roger Messner, John Thompson Jr., Doug Schaper, and Greg Nussle.

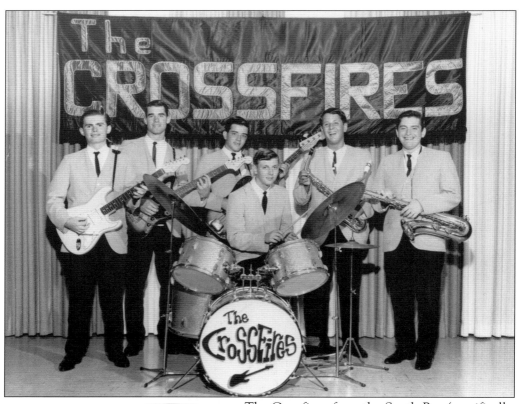

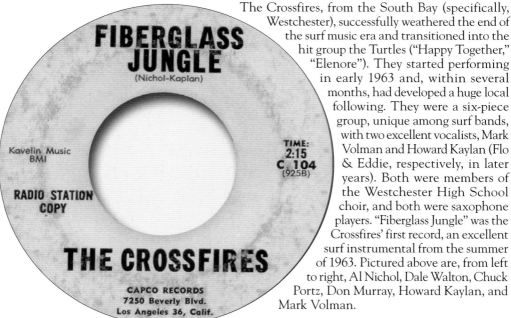

FIBERGLASS JUNGLE
(Nichol-Kaplan)

Kavelin Music
BMI

RADIO STATION
COPY

TIME:
2:15
C 104
(925B)

THE CROSSFIRES

CAPCO RECORDS
7250 Beverly Blvd.
Los Angeles 36, Calif.

The Crossfires, from the South Bay (specifically, Westchester), successfully weathered the end of the surf music era and transitioned into the hit group the Turtles ("Happy Together," "Elenore"). They started performing in early 1963 and, within several months, had developed a huge local following. They were a six-piece group, unique among surf bands, with two excellent vocalists, Mark Volman and Howard Kaylan (Flo & Eddie, respectively, in later years). Both were members of the Westchester High School choir, and both were saxophone players. "Fiberglass Jungle" was the Crossfires' first record, an excellent surf instrumental from the summer of 1963. Pictured above are, from left to right, Al Nichol, Dale Walton, Chuck Portz, Don Murray, Howard Kaylan, and Mark Volman.

STOMP
WITH THE
CROSSFIRES
SAT. MAR. 14TH - 8:00 TO 12:00
AT THE
MASONIC LODGE
7726 W. MANCHESTER
PLAYA DEL REY
JUST WEST OF WESTCHESTER HIGH
NO LEVIS OR CAPRIS
DONATION $1 50

For most of 1963 and 1964, the Crossfires were a very busy surf band. They played every weekend at teen clubs (such as the Revelaire in Redondo Beach), Masonic lodges, the Retail Clerks Union Hall Auditorium in Buena Park, and many of the area's high schools. The Revelaire Club, in fact, was where the band first performed as the Turtles (in mid-1965). The Crossfires backed up Kathy Marshall at a number of shows here and in Hawaii. This poster is from March 1964, when some dances (featuring a surf band, of course) were still being described as "stomps."

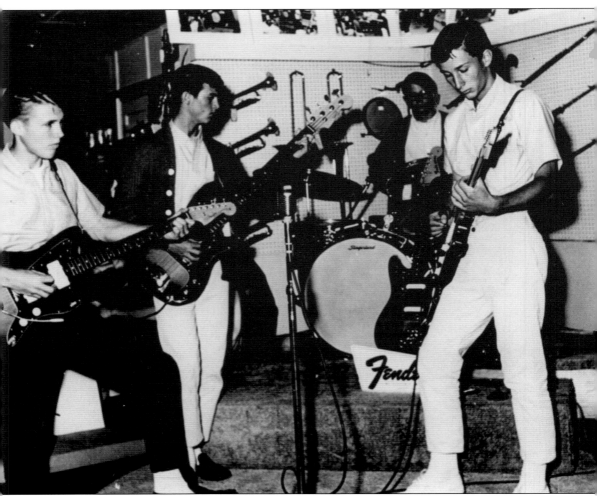

The surf music genre provided the training ground for many young musicians and singers to develop successful careers in the music business. One of those was Jim Messina, the producer/guitarist who became known for his work with Kenny Loggins, Poco, and Buffalo Springfield. He assembled his first band, the Jesters, fresh out of high school in Fontana in late 1963. (Part of the vast Inland Empire area, Fontana was home to the huge Kaiser Steel mill and was a regional hub for the trucking industry.) His was one of the very few surf bands to feature three guitarists, which simply added to the urgency of the music. Here, Messina (far right) jams with unidentified friends at Lier's Music Store in San Bernardino.

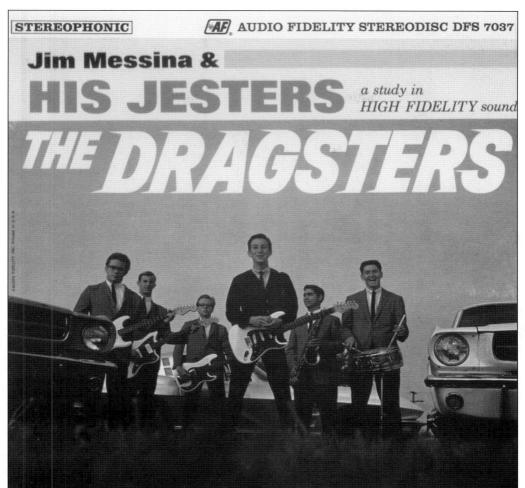

STEREOPHONIC ▮AF▮. AUDIO FIDELITY STEREODISC DFS 7037

Jim Messina &
HIS JESTERS *a study in* *HIGH FIDELITY sound*
THE DRAGSTERS

Jim Messina & the Jesters' only album, *The Dragsters*, was released in 1964. The record has become legendary due to Messina's post-surf music curriculum vitae and the excellent examples of instrumental surf recorded here. "The overall effect is one of controlled frenzy," stated the album's liner notes. It was released on the Audio Fidelity label, which had the first commercial stereophonic vinyl record in 1957 and is frequently associated with sound-effects compilations. *The Dragsters* is not really a hot rod record; only half of the instrumental tracks have dragster-related titles. Still, it is perhaps no surprise that the music was blended with sports car and racing sound effects. Seen on the album cover are, from left to right, Bill Beckman, Ron House, Jim Sholstedt, Messina, Dave Archuleta, and Larry Cundieff.

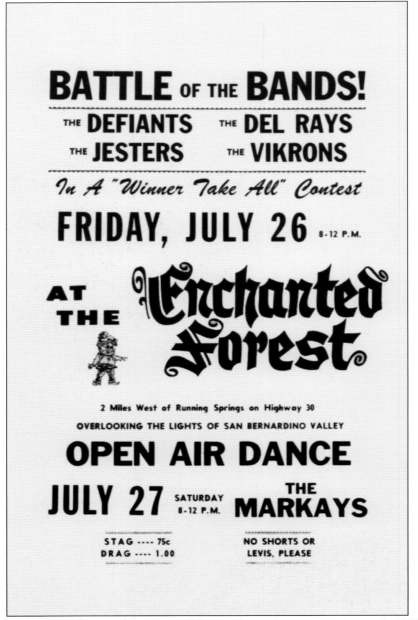

The "Battle of the Bands" concept originated during the surf music era of the early 1960s. It was usually a semiformal contest to determine the "best" band out of a group of bands performing in front of an audience. It was a way to promote a show and attract the greatest number of kids, who would vote to determine the winner of the contest at the end of the night. The band that came out on top most frequently won only bragging rights, but there were contests in which prizes were also awarded. The Enchanted Forest was an interesting location for a band "battle." At 5,000 feet in the mountains overlooking San Bernardino, the Enchanted Forest was the location of Santa's Village Theme Park, which had opened in 1955 and remained a popular attraction for the next 43 years.

Among the largest "Battle of the Bands" was the one held at the Deauville Castle Club in Santa Monica in the spring of 1963. A whopping 18 bands were featured in this contest, held over three nights, with a winner chosen each night. Most of the bands were Southern California outfits, but some came from central and northern California. The Friday night winners (the Rhythm Kings, who were from Delano in the Central Valley) and the Saturday night winners (Dave Myers & the Surftones from Orange County) were recorded live and featured on a subsequent long player, appropriately titled *The Winners of the 18 Band Surf Battle!* This was one of the very few live recordings of surf bands from that time period.

"SURF BATTLE"

FRI. Mar. 22 (8:00 P.M.) **SAT. Mar. 23** (8:00 P.M.) **SUN. Mar. 24** (2:00 P.M. - ?)

DEAUVILLE CASTLE CLUB

1525 Ocean Front in Santa Monica
Where Olympic Blvd. Meets The Surf

COMPETING FOR #1 IN THE SURFIN' WORLD

The RHYTHM KINGS
The LIVELY ONES
The SENTINALS
Bob VAUGHT and the Renegaids
DAVE MEYERS and the Surftones
The BREAKERS
The RHYTHM ROCKERS
The CHANTAYS

HORACE HEIDT JR. and the TRADE WINDS	JIM WALLER and the DELTAS
THE CHARADES	THE PERSUADERS
THE RHYTHM CRUSADERS	THE HOLLYWOOD SURFERS
THE STING RAYS	THE SURFAIRIS
THE GOLDEN NUGGETS	THE CENTURIANS
	DANNY and the SESSIONS

TEEN SURFERS ONLY (14-19)
(HODADS NOT WELCOME)

All From The KFWB Battle of the Surf Bands
on Delfi Records
All from "Original Surfin' Hits"
on Cresendo Records

FREE SURF MOVIES IN COLOR

CRESCENDO RECORDS

THE WINNERS OF THE 18 BAND **SURF BATTLE!**

RECORDED LIVE AT THE DEAUVILLE CLUB SANTA MONICA CALIFORNIA MARCH 22ND AND 23RD 1963

FRIDAY NIGHT WINNER **THE RHYTHM KINGS**
SATURDAY NIGHT WINNER **DAVE MYERS & THE SURFTONES**

Rendezvous Scheduling Popular Bands, Singers

Balboa's Rendezvous ballroom, long criticized as a hangout for rowdy teenagers and way - out music, is now scheduling name bands and popular singers to appeal to a more varied audience.

Paul Peterson, the Righteous Brothers, Jan and Dean, the O'Jays, and Shelly Fabares are just a few of the well known performers who have been appearing at the Rendezvous.

"Early in December of last year," explained Mr. John Clark, manager of the Rendezvous, "I arranged with three KFWB disc - jockeys, Gene Weed, Jimmy O'Neill, and Sam Riddle, to bring down entertainment from Los Angeles every Friday night."

"Eventually we hope to have such people as the Beach Boys and Joe and Eddie," said Mr. Clark. "We would like to try having hootenannys and it seems as though they might be successful since kids as well as adults in the Newport area are becoming interested in folk music."

Through 1963 and into 1964, dancing continued at the Rendezvous Ballroom, featuring surf bands every weekend. But the music scene and what was heard on transistor radios was changing. Trying to shake its long-standing reputation as a weekend nuisance for local residents, the Rendezvous started to bring in more "class" acts, such as the Righteous Brothers, Paul Peterson, Jackie DeShannon, Jan & Dean, and Shelly Fabares. There was a thriving folk-music scene at the time (led by the Kingston Trio and Peter, Paul & Mary), so there was also an interest in bringing folk music acts to the Rendezvous. (Courtesy of the *Beacon*, Newport Harbor High School.)

Four

BEYOND THE TEENAGE FAIR

The word "teenager" was coined in the 1950s to describe the growing population of 13 to 19 year olds in the years following the end of World War II. Teenagers developed a new affluence and a cultural aloofness, based primarily on music (rock 'n' roll) and cars (hot rods) that set them apart from their parents. The commercial exploitation of that affluence would become a natural extension of the culture by the 1960s.

It did not take long before companies that catered to elements of teen culture, such as music and dress, began to creatively market their products directly to teenagers. In Southern California, one of the first major examples of this was the Teenage Fair, a weeklong event that was held annually during Easter vacation between 1962 and 1972. The Teenage Fair featured everything under the sun of importance to teenagers, including the surfing experience.

A string of "beach party" movies began in 1963 that spoofed the teenage experience in Southern California. "Fun" was still the operative word. Local television programs appeared in Los Angeles aimed at a teenage audience. Along with the nationally televised *American Bandstand*, some Los Angeles television programs were also teenage dance programs, while others focused on surfing; but all of them featured Southern California surf bands at one time or another (the Beach Boys and the Pyramids also made appearances on *American Bandstand*). There were live television broadcasts from the Teenage Fair, which also featured the Miss Teen USA pageant as part of the weeklong event.

The explosive popularity of surf music caused Fender Musical Instruments to shift its marketing strategy. Instead of targeting mainly country-western and rockabilly artists with their advertising and outreach programs, as was done in the 1950s, Fender started marketing directly to teenagers in the 1960s, and sales of guitars dramatically increased. The thrust of that advertising campaign was credited to Robert Perine, Fender's art director at the time. Perine wanted to use teenagers in the Fender magazine advertisements, because, as he has said, "they were basically the market." Instead of using professional models, Perine "had three daughters that were going to Laguna Beach High School, so I had sort of built-in helpers . . . to find the right faces and the right types."

In many respects, however, it was too little, too late by 1964. Campaigns that should have started a year or two earlier found it more difficult to market surf music to an audience that was rapidly starting to turn its attention to England. The texture of Top 40 radio was dramatically changing. Advertising money went to the music that record companies wanted to promote, which was the music teenagers were buying. Surf music started to take a backseat to British rock. But it took awhile to taper off. Surf bands, although fewer in number, were still promoting themselves, making records, and performing at dances/stomps well into 1965 and 1966.

The bands realized that self-promotion was needed if they wanted to spread their music beyond the city limits. Most bands had business cards printed with nifty little catchphrases, such as, "The

Wild Sounds of . . .," "America's No. 1 Show Band" (there were many of these!), "Dance to the Rocking Sounds of . . .," or the to-the-point "Surf Band." The very real goal, though, for many surf bands was to make a 45 rpm record to sell at their dances and, hopefully, have it played on a local radio station. All that was needed was a little money to pay for a recording studio (in those days, an inexpensive two- or three-track studio might have cost $10 to $15 per hour), print some labels, and press a couple of hundred copies of the record. While a number of bands across the country released surf instrumental recordings, the majority were issued by local Southern California bands.

This helped to create a number of independent recording studios in Southern California. There were also a half dozen record-pressing plants in Southern California that serviced the increasing number of recordings being produced in the early 1960s. All of this contributed to the West Coast overcoming New York as the recording center of the country.

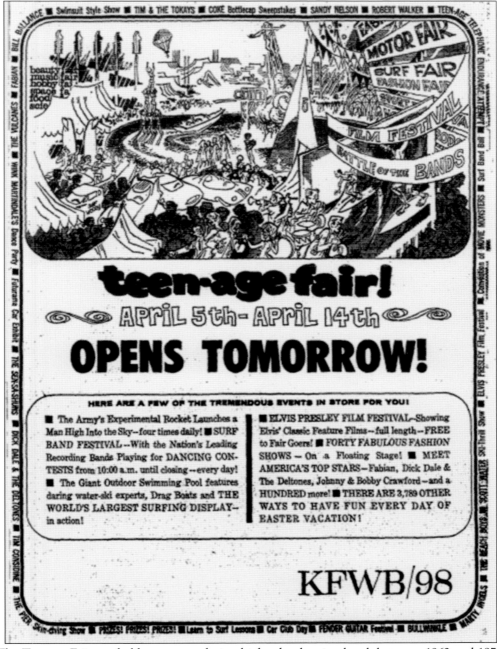

The Teenage Fair was held every year during high school spring break between 1962 and 1972. The first one, at Pacific Ocean Park, successfully attracted over 250,000 kids. In 1963, the event moved to Pickwick Park in Burbank, then to the Hollywood Palladium the following year, where it remained until 1972. Radio station KFWB was a primary sponsor of the 1963 Teenage Fair, which featured an Elvis Presley film festival, a Battle of the Bands, a daily demonstration of the Army's new human-propulsion rocket pack, water-sports demonstrations in a huge outdoor swimming pool, fashion shows, and surf bands playing from 10:00 a.m. until closing every day!

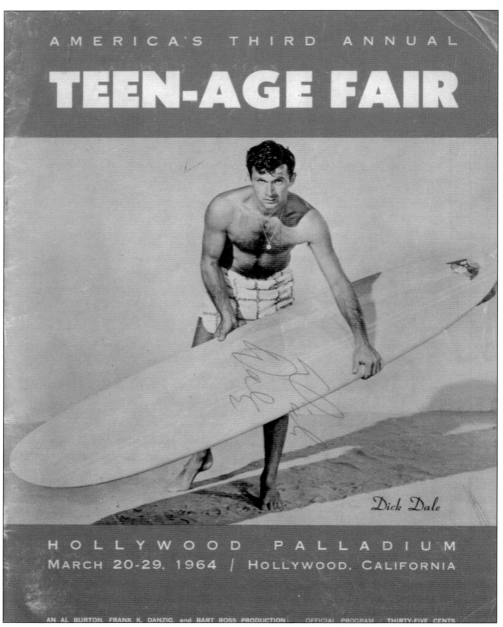

AMERICA'S THIRD ANNUAL

TEEN-AGE FAIR

Dick Dale

HOLLYWOOD PALLADIUM
MARCH 20-29, 1964 / HOLLYWOOD, CALIFORNIA

AN AL BURTON, FRANK K. DANZIG, and BART ROSS PRODUCTION OFFICIAL PROGRAM / THIRTY-FIVE CENTS

Dick Dale graced the cover of the program booklet for the 1964 Teenage Fair. Over 100 major manufacturing and business firms presented over $3 million in "automotive, space, science, sports, music, fashion, radio, and television" exhibits. All of it was intended expressly for a teenage audience. More than 300,000 visitors were expected to pass through the doors. The Beatles held the top four positions on the *Billboard* Top 100 chart, and the Beach Boys' "Fun Fun Fun" peaked at No. 5 in the last week of March, but the majority of bands that played at the fair that year were surf bands (the Pyramids' "Penetration" was the only surf record in the Top 40.) The event was so important that Mayor Sam Yorty proclaimed March 20–29 as "Teen-Age Fair Days" in the city of Los Angeles.

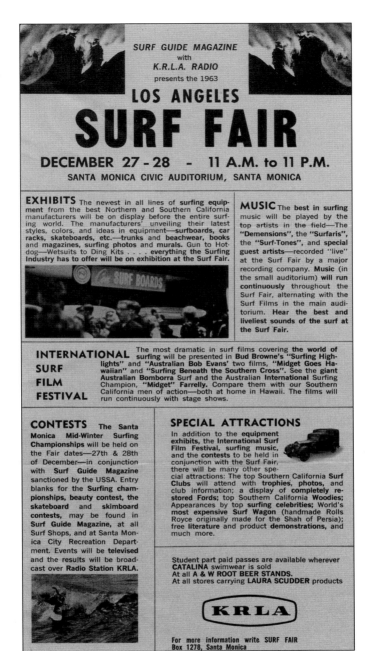

SURF GUIDE MAGAZINE
with
K.R.L.A. RADIO
presents the 1963

LOS ANGELES
SURF FAIR

DECEMBER 27 - 28 - 11 A.M. to 11 P.M.
SANTA MONICA CIVIC AUDITORIUM, SANTA MONICA

EXHIBITS The newest in all lines of surfing equipment from the best Northern and Southern California manufacturers will be on display before the entire surfing world. The manufacturers' unveiling their latest styles, colors, and ideas in equipment—surfboards, car racks, skateboards, etc.—trunks and beachwear, books and magazines, surfing photos and murals. Gun to Hot-dog—Wetsuits to Ding Kits everything the Surfing Industry has to offer will be on exhibition at the Surf Fair.

MUSIC The best in surfing music will be played by the top artists in the field—The "Demensions", the "Surfaris", the "Surf-Tones", and special guest artists—recorded "live" at the Surf Fair by a major recording company. **Music** (in the small auditorium) **will run continuously** throughout the Surf Fair, alternating with the Surf Films in the main auditorium. **Hear the best and liveliest sounds of the surf at the Surf Fair.**

INTERNATIONAL SURF FILM FESTIVAL The most dramatic in surf films covering **the world of surfing** will be presented in **Bud Browne's "Surfing Highlights"** and **"Australian Bob Evans'** two films, **"Midget Goes Hawaiian"** and **"Surfing Beneath the Southern Cross".** See the giant Australian Bomborra Surf and the Australian International Surfing Champion, **"Midget" Farrelly.** Compare them with our Southern California men of action—both at home in Hawaii. The films will run continuously with stage shows.

CONTESTS The Santa Monica Mid-Winter Surfing Championships will be held on the Fair dates—27th & 28th of December—in conjunction with **Surf Guide Magazine** sanctioned by the USSA. Entry blanks for the **Surfing championships, beauty contest, the skateboard** and **skimboard contests,** may be found in **Surf Guide Magazine,** at all Surf Shops, and at Santa Monica City Recreation Department. Events will be **televised** and the results will be broadcast over **Radio Station KRLA.**

SPECIAL ATTRACTIONS
In addition to the **equipment exhibits,** the International **Surf Film Festival,** surfing music, and the **contests** to be held in conjunction with the Surf Fair, there will be many other special attractions: The top Southern California **Surf Clubs** will attend with **trophies, photos,** and club information; a display of **completely restored Fords;** top Southern California **Woodies;** Appearances by top **surfing celebrities;** World's most expensive **Surf Wagon** (handmade Rolls Royce originally made for the Shah of Persia); free **literature** and product **demonstrations,** and much more.

Student part paid passes are available wherever **CATALINA** swimwear is sold
At all **A & W ROOT BEER STANDS.**
At all stores carrying **LAURA SCUDDER** products

KRLA

For more information write SURF FAIR
Box 1278, Santa Monica

Today, they are called "trade shows" or "expos," but in the 1960s, they were "fairs." The first Los Angeles Surf Fair was held at the Santa Monica Civic Auditorium in December 1962 (the Beach Boys headlined). The event featured manufacturers' displays, surfing movies, and surf bands. The fair was held for two more years in the same place before it become unprofitable. The target audience, for marketing purposes, seemed to be much narrower than that of the Teenage Fair: surfing culture instead of teenage culture (although, in Southern California, there was a lot of crossover). Shown here is a flyer for the 1963 Surf Fair that promotes the event as having "everything the Surfing Industry has to offer."

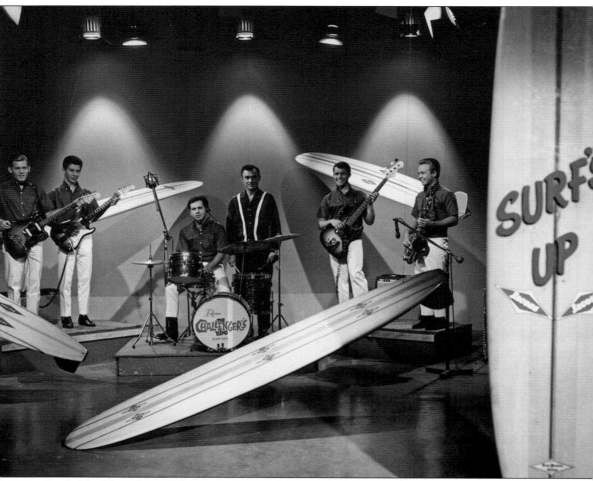

Surf's Up debuted on KHJ-TV in Los Angeles in June 1964 as a half-hour program on Saturday evenings. Originally hosted by surfing-movie filmmaker Walt Phillips, it became a one-hour show on Sunday evenings in August. KHJ radio disc jockey Stan Richards took over as the show's host, and the Challengers became the house band, playing live every week. The show featured clips from current surfing movies, news about upcoming surfing events, and in-studio guests. Shown here on the set of *Surf's Up* are, from left to right, Ed Fournier, Art Fisher, Richard Delvy, host Stan Richards, Randy Nauert, and Phil Pruden. (Courtesy of Randy Nauert.)

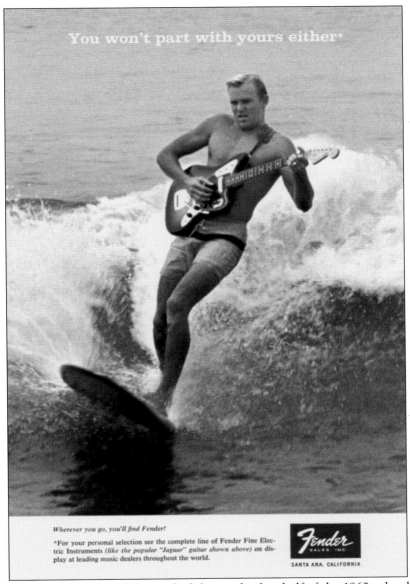

Wherever you go, you'll find Fender!

*For your personal selection see the complete line of Fender Fine Electric Instruments (like the popular "Jaguar" guitar shown above) on display at leading music dealers throughout the world.

Fender SALES, INC.

SANTA ANA, CALIFORNIA

Sales of Fender guitars and amplifiers spiked during the first half of the 1960s, thanks in great part to surf music. It was only natural that the company's advertising focus shift to target the teenage consumer. That was the intention behind the highly successful "You Won't Part With Yours Either" advertising campaign created by Robert Perine, Fender's lead graphic designer. Perine told *Vintage Guitar* magazine in 1997 that Fender's "[Don] Randall and [Stan] Compton emphasized the teenage market was of vital importance because kids in every major city were being encouraged by dealers to take guitar lessons, so I slanted many of the ads towards them, going to teenage fairs in Southern California, finding teen models, putting them in situations where the guitars looked user-friendly. . . . I conceived the idea of doing a series of ads that would photographically show this relationship of guitar to player. Wouldn't it be interesting, I thought, to depict musicians of all ages unwilling to leave their wonderful, precious Fender guitars unattended." (Courtesy of Fender Musical Instruments.)

SURFING SCENE

Coast Craze Adds Hearse

HOLLYWOOD—Bob Keene's Del-Fi Records will give away a "surfin' hearse" to a record buyer here as part of a three-way promotional tie-in between the label, the Music City Stores and Station KFWB. Stunt arises from the current craze among Southern California teen-age surfers to acquire used hearses to cart their surfboards to the beach. Same contest will be staged in other cities.

Promotion is aimed at spotlighting Del-Fi's surf artists, the Lively Ones, and the label's surf-heavy product line-up. To win the Del-Fi hearse, youngsters can pick up entry blanks at any of the three Music City stores. Music City is backing up the contest with heavy in-store displays of Del-Fi's surfing line, with particularly emphasis on the label's current sellers, "Battle of the Surf Bands" and "Surf Drums."

The station's part in the giveaway is through its "KFWBeach Patrol" and its "Club 98" promotions through which it has scheduled hour plugs on the "Surfin' Hearse" by all its deejays each day for three weeks. On June 8, KFWB jockey Joe Yokum will draw entry blanks from a bowl to announce the winners.

First prize is the hearse, a 1948 Packard funeral wagon, with surfboards as second prizes. Next week, Keene will stage a similar giveaway promotion of hearse and boards in San Francisco, in a tie-in with the Emporium Store.

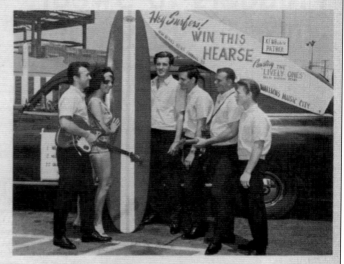

HEARSE GIVEAWAY: The prize is inspected by Del-Fi's "Surfing Queen," Rachel Romen, second from left, and label's group, the Lively Ones—Ed Chiaverini, Ron Griffith, Joe Willenbring, Jim Masoner and Tim Fitzpatrick.

There are approximately 100,000 surfers in Southern California today, a sport which has created its own music, its own language and "uniform," and a thriving industry. Last year there were only five surfboard manufacturers in the Los Angeles area. Today more than 100 firms make the boards. Two magazines are published here devoted exclusively to surfing. One boasts a circulation of 65,000. Scores of surfing shops have opened along the California beaches to service the surfers.

Oddest development in the surfing craze has been its affect on the used car business. Until recently, an old hearse was about the deadest item on the used car market, with wood paneled station wagons following a close second. Today, used hearses are snapped up by the surfers as coveted "board buggies," and as a surfer's status symbol outclasses the "woodies" (panel wagons).

The stereotyped, although popular, mode of transportation used by Southern California surfers has always been the "woodie," a station wagon with wood exterior paneling. Presumably because it had enough cargo space for a passel of surfboards—or a band and all its gear, for that matter—the hearse also became associated with the surfing/surf music crowd. As described in this *Billboard* magazine article from June 1963, Del-Fi records launched a major local promotional tie-in with radio station KFWB and Wallich's Music City stores in Southern California. Note the interesting demographics cited in this article. Surf music really had nothing to do with surfing, apart from the artistic connection.

Five

THE WOMEN OF SURF MUSIC

The early surf bands maintained the electric guitar's status as the lead instrument, as established by the rock 'n' roll and rockabilly bands of the 1950s. For reasons open to conjecture, the guitar seems to have always been a primarily male muse. In 2003, *Rolling Stone* magazine's list of the top 100 guitarists of all time included only two women (Joni Mitchell and Joan Jett).

Few women felt empowered or inspired enough to pick up an electric guitar until the 1970s with artists such as Nancy Wilson, Bonnie Raitt, or Lita Ford, etc. Perhaps the women's liberation movement caused some teenage girls to see the transformative nature of playing rock guitar, suggested by the lyrics to Mary Chapin Carpenter's 1994 composition "Girls With Guitars":

> Well, Saturday nights she followed her brother,
> It was socks and stockings on the old gym floor,
> While everybody danced to garage band covers,
> She was checking out riffs and memorizing chords.
> She didn't care at all for the football heroes,
> She didn't even notice the basketball stars,
> Boys as a species were all a bunch of zeros,
> Except for the ones that played that guitar.

In the 1950s, however, pre–rock 'n' roll trailblazers such as Mary Ford, Sister Rosetta Tharpe, Lorrie Collins, and Peggy Jones ("Lady Bo," a member of Bo Diddley's band) all wielded a guitar. Certainly, the most recorded female string bender of all time is session bassist Carol Kaye, who actually started in 1957 by playing guitar in jazz bands. She played bass on a lot of surf music recordings, too.

Nationally, it was a very small and unique group of female guitarists who played in instrumental surf bands. There were only a couple of them in Southern California, but they certainly held their own with the boys. Unfortunately, the most widely recognized female surf guitarist, Kathy Marshall, did not have a chance to pass through a recording studio. She did leave behind a well-documented history that has ensured her status as a legend of the genre. Chiyo Ishi was the lead guitarist in the Crescents, a surf band from Ventura. She taught guitar at her own music store and has the distinction of having a national Top 100 record, December 1963's "Pink Dominos."

Interestingly, Hawaii, which achieved statehood in 1959, had an overabundance of surf bands in the early 1960s, with a number of female musicians and singers in their ranks, including the all-female Angie & the Originals. Other Hawaii surf bands that featured female singers and/or musicians included the Impacts (Bonnie Connor), the Frolic Five (Pearl Miyashiro, Charlene McCabe, and Marsha Kalima), the Lepricons (Cynthia Herolaga), Judy & the Belmonts (Judy Cuales), and Denny & the Dukes (Cheyenne Ragil).

Consistent with the typical female role in popular music, most of the women who made surf records in the early 1960s were solo vocal artists using well-produced and orchestrated backing tracks. Singers such as Annette (Funicello), Carol Connors, Donna Loren, and Kathy Brandon recorded songs about the surfing/beach lifestyle, but they were not necessarily known as surf music artists. There was a smaller number of traditional female trios, such as the Beach Girls, Delicates, Surfer Girls, Petites, and the Westwoods. These groups were known as surf music artists, by virtue of one or two records intentionally produced in Southern California to take advantage of the popularity of the genre.

The most well-remembered female group in surf music was surely the Honeys (surfer jargon for girl surfers), from Los Angeles. *Music Vendor* magazine, in an April 1963 article, called the Honeys "the world's first female surfing vocal combo." The group's first single for Capitol Records was released in April 1963. The record did nothing in the States, but it cracked the Top 10 in Denmark, of all places. Despite being produced by the Beach Boys' Brian Wilson, the Honeys had much greater success as backing vocalists for recording sessions by artists such as Annette, Shelley Fabares, Paul Peterson, and even the Surfaris.

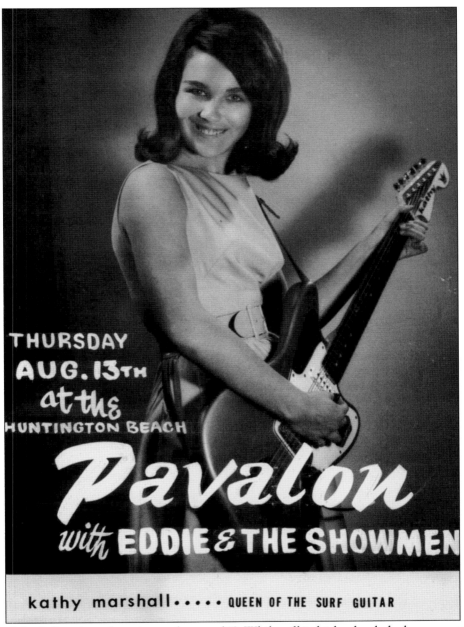

THURSDAY
AUG. 13TH
at the
HUNTINGTON BEACH
Pavalon
with EDDIE & THE SHOWMEN

kathy marshall..... QUEEN OF THE SURF GUITAR

Kathy Marshall took up the guitar at the age of 13. While still in high school, she became a minor celebrity in Orange County as "Queen of the Surf Guitar" (a title bestowed upon her by Dick Dale). She garnered a lot of notoriety and local press coverage as she started to perform frequently with the Blazers and Eddie & the Showmen. She appeared on stage with a number of other surf bands, including the Crossfires, Nocturnes, Chevells, Baymen, PJ & the Galaxies, and even the Beach Boys and Dick Dale. This handbill was for her appearance at the Pavalon Ballroom with Eddie & the Showmen on August 13, 1964. Her talent at playing surf guitar was highly regarded by many, including the surf bands that were lucky to have backed her on stage. Sadly, Marshall left no recordings behind. (Courtesy of Kathy Marshall.)

KATHY MARSHALL

. . . plays tonight for teen dance

Surfer Queen Sings Tonight

Queen of Surf Guitar is a title won earlier this summer by pretty Kathy Marshall, daughter of Mr. and Mrs. Paul Marshall of 1434 Lael St., Orange.

The young musician, who is only 14-years-old, attends Yorba Junior High School and will enter 9th grade in September.

She will appear tonight at the Retail Clerks Union hall in Buena Park as guest artist with Eddie and the Show Men at a regular teen dance.

Kathy has been playing for four years, but has appeared in public for the past year. She won her title at the Rollarena in Bellflower, and also appeared during Easter vacation at the Hollywood Paladium.

Kathy Marshall, "Queen of the Surf Guitar," was a true surf music legend in Southern California, because she was so unique. She would have been simply a novelty act if she had not been so good at playing guitar. In recent years, Marshall has said, "I didn't want to be better than the boys; I just wanted to be as good as the boys." Regardless, almost every one of her appearances through 1964 and into 1965 garnered plenty of attention in local newspapers, and she was highly respected by those in the Orange County surf music scene. (Courtesy of Kathy Marshall.)

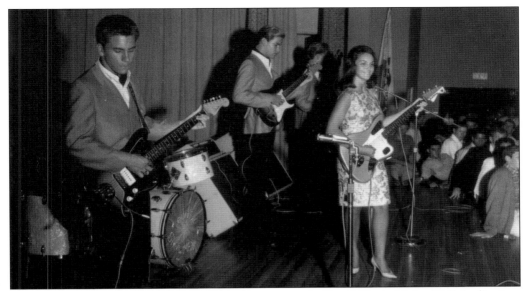

Kathy Marshall performs with Eddie & the Showmen at the Retail Clerks Union Hall Auditorium in Buena Park. Note the custom-painted Fender Jaguar guitar with her name emblazoned on the headstock. Not everyone could afford to have such a guitar, however. The major players who did were Dick Dale, Eddie Bertrand, and Marshall. Pictured are, from left to right, Larry Carlton, Mike Mills (on drums behind Carlton), Rob Edwards, Doug Hensen, and Marshall. (Courtesy of Kathy Marshall.)

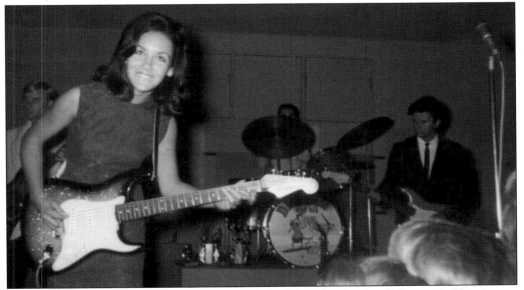

Kathy Marshall appears on stage with Dick Dale (right) at the Pavalon Ballroom in Huntington Beach. Dale was dubbed "King of the Surf Guitar" by those who came to see him at the Rendezvous Ballroom, and it was he who bestowed the title "Queen of the Surf Guitar" on Marshall. Here, she is playing her custom-painted Fender Stratocaster. Dick Dale's Stratocaster was also custom-painted at the Fender factory, but in a bright gold finish called chartreuse sparkle He continues to play that guitar today. (Courtesy of Kathy Marshall.)

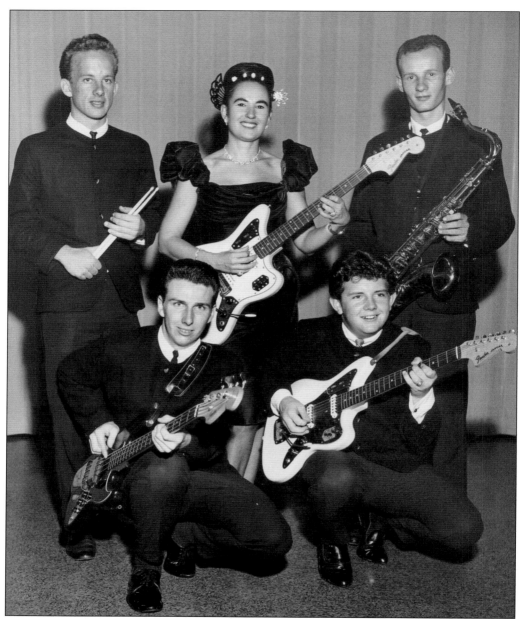

Kathy Marshall was not the only female surf guitar player in Southern California at the time, but she got most of the attention, despite not having released any recordings. Chiyo Ishi, on the other hand, was a highly talented guitarist who made several records with her band, the Crescents, one of which made the charts. "Pink Dominos" reached No. 69 on the *Billboard* Top 100 in November 1963. The band was from Ventura, north of Los Angeles, where Ishi (originally from Arizona, of Hopi Indian extraction) taught guitar at her music store in Oxnard. Shown here are, from left to right, (first row) Tom Mitchell and Thom Bresh; (second row) Bob Ross, Ishi, and Ray Reed. Bresh was the son of country-western guitarist Merle Travis. Note the Beatles-styled collarless jackets, which became very popular in early 1964. (Courtesy of Michael Aitchison.)

For various reasons besides the "cool factor," many surf bands traveled to gigs in old hearses (this was even more common among non-surf garage bands in the late 1960s). Shown above is the 1949 Packard hearse used by Chiyo & the Crescents. These cars were over 6 feet tall, 6.5 feet wide, and over 20 feet long, providing plenty of space for gear and band members. The rear side windows sport placards with the band's name and the title of their hit record, "Pink Dominos," which was actually released twice. The first time was on the band's own label, Breakout, featuring "Devil Surf" as the flipside. The second release, which was nationally distributed, became the hit, but it had a different flipside. "Devil Surf" was one of the best, and more obscure, surf instrumentals of 1963. (Above, courtesy of Thom Bresh.)

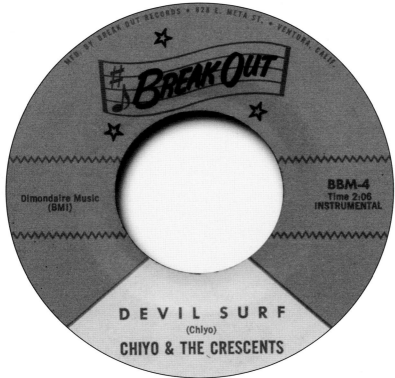

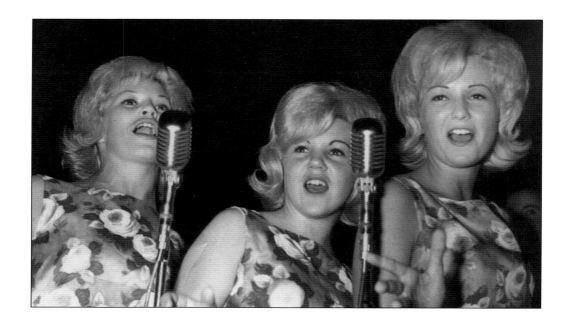

Kathy Marshall and Chiyo Ishi were the two more memorable female lead guitar players in Southern California surf bands. Vocally, however, there were quite a few women who made surf records, although not many were actually about the surfing experience. Among the top female surf music vocal trios were the Surf Bunnies (above) and the Honeys (below). The latter were protégés of Brian Wilson of the Beach Boys, who also produced their recordings. The Surf Bunnies were, from left to right, Pat Kent, Patty Brown, and Donna Schultz. The Honeys were, from left to right, Marilyn Rovell, Diane Rovell, and Ginger Blake. Rovell married Brian Wilson in late 1964. (Above, courtesy of Donna Schultz.)

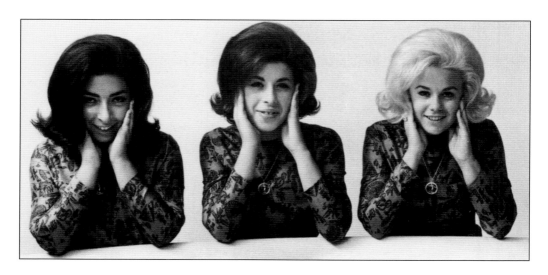

The Surf Bunnies were longtime friends and classmates at El Monte High School who decided to sing together at various teen clubs and youth centers following their graduation in 1962. They were brought to Goliath Records in early 1963 by songwriter Barry Richards to record two of his surfing songs, "Our Surfer Boys" and "Surf Bunny Beach," backed by a Los Angeles surf band called the Vulcanes. The record was picked up for national distribution by Dot Records, but success never came, despite one follow-up single at the end of the year. The Honeys, composed of two sisters and a cousin, recorded two surf records in 1963; the first was "Shoot the Curl." They were also very prolific backing vocalists in the studio, having appeared on records by Lou Rawls, the Surfaris, Annette, Jackie DeShannon, and the Beach Boys, among others.

Female surf music vocals were, for the most part, about boyfriends and spending time at the beach, a somewhat romantic notion for a teenager in Southern California at the time. Carol Connors was a Los Angeles songwriter/vocalist best remembered as the lead voice on the Teddy Bears' major hit of 1959, "To Know Him Is to Love Him." She wrote a number of hot-rod songs in the 1960s, including the Ripchords' "Hey Little Cobra." Her "Lonely Little Beach Girl" was a latecomer from 1966. Dee D. Hope's 1963 recording of "California Surfer" describes the surfers' dress code, compared to that of the "ho-dads." Both records are obscure relics of a time and culture when teenagers were focused on simpler ideals.

By the spring of 1964, the Beach Boys had achieved four hit records, two of them in the Top 10 nationally. They were, according to pundits at the time, America's answer to the Beatles. It is no surprise, therefore, to see a tribute record to the band by a female trio called the Sea Shells. Pat Kent (formerly of the Surf Bunnies), Kaylene Akeima, and an unknown third vocalist were put together specifically for this recording. Annette (Funicello) was, of course, a former Mouseketeer and the star of several "beach party" movies (including *Muscle Beach Party*). She released quite a few teen-oriented recordings, many of which made the pop charts between 1959 and 1961.

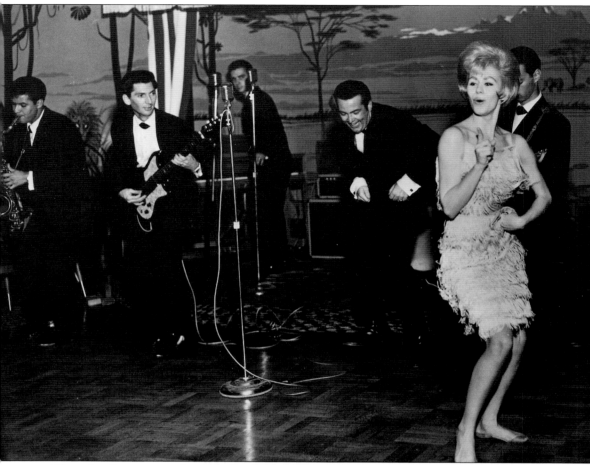

The role of women in the early Southern California surf music scene was, for the most part, relegated to studio recordings. It was rare to see a woman on stage playing a guitar and not singing. Candy Johnson achieved fame by not being a musician or a singer. She had studied dancing in school since an early age and gained notoriety during a 1962 engagement at the El Mirador Hotel in Palm Springs with her band, the Exciters (shown here). It was there that she was seen by the head of American International Pictures, who offered her a role in the second "beach party" film, *Muscle Beach Party*. Appearances in both *Bikini Beach* and *Pajama Party* followed. She was billed as "Miss Perpetual Motion" and, according to songwriter/producer Gary Usher, "she could sure shake up a storm. That was her whole scene. She just danced and wiggled [and] would sometimes lose up to seven to ten pounds during her act." Dancing and having fun, after all, were what Southern California surf music was all about. (Courtesy of Red Gilson.)

Six

SUNSET

The surf music era started to wind down by early 1964, taking a bit more time on the West Coast than in the rest of the country. A strong, national acceptance of the instrumental musical form was difficult, since it was tied so strongly with a lifestyle and geography indigenous to Southern California. Whatever momentum it had in 1963 suddenly changed after the assassination of President Kennedy in November. The war in Vietnam grew into more of a social and political issue, and the Watts riots in August 1965 helped to erode more of the idealism.

One of the most important events that turned everyone's attention away from surf music, and every other indigenous form of American popular music at the time, happened on February 9, 1964. The Beatles made their first appearance on *The Ed Sullivan Show* that Sunday night, and 73 million people watched, following weeks of eager anticipation. When the sun rose the next morning, American kids woke up to a different world.

The Beatles and Motown did more, perhaps, to change musical tastes than anything else. The Beatles were all over the radio in January 1964. "I Want To Hold Your Hand" shot to No.1 on the *Billboard* charts, followed in quick succession by "I Saw Her Standing There" and "She Loves You" before month's end; they had nearly 30 records in the Top 100 that year. The Supremes, the Four Tops, Stevie Wonder, and Marvin Gaye, among others, took the "Motown sound" to the top of the charts, as well. The Rolling Stones had their first Top 10 hit by October, and the Beatles' first movie, *A Hard Day's Night*, was released in August. Surf music was pushed aside, and the demand for surf bands to hold sway over "surfer stomps" started to wane.

Not just the music, but youth culture was quickly changing as well. By 1965, clothing and hairstyles were dramatically different than they had been only two years earlier. Civil rights marches, the Vietnam War, and the loss of Robert Kennedy and Martin Luther King cast a deeper pall over the cultural optimism that had been so pronounced earlier in the decade. Many of those who were still playing in surf bands at the end of 1964 simply put their guitars away in favor of other pursuits or because the draft was calling. As the war in Vietnam escalated, the draft call-up became a matter of concern for a large number of male baby boomers who graduated from high school in 1964 and 1965.

As if the Beatles and the ensuing invasion of British rock bands, weren't enough, the folk-rock genre captured attention in early 1965. A lot of surf guitarists traded in their Fender guitars for Rickenbacker 12-strings in the wake of the Byrds, Jefferson Airplane, the Leaves, and Beau Brummels. The Fender Reverb was quickly replaced by fuzz-tone pedals. Psychedelic music and protest songs were right around the corner. The music turned away from the beaches.

Dick Dale's last album of the decade was released in the spring of 1965. It was a live recording from an appearance at the Ciro's Le Disc nightclub in Los Angeles. Only four of the eleven

tracks on the record were instrumental. Of the vocals, most were rhythm and blues staples such as "Money" or "What'd I Say," with a somewhat incongruous cover of Bob Dylan's "Blowin' in the Wind."

Nevertheless, dancing continued at the Rendezvous Ballroom every weekend. That is, until the early-morning hours of Sunday, August 7, 1966. A cigarette, not fully extinguished from the night before, was the apparent cause of a fire that destroyed the building. The Rendezvous Ballroom, where Dick Dale & the Del-Tones made surf music history in 1960 and 1961, was gone. The night before had been just another celebration of fun and dancing, with music by the current Rendezvous house band, the Cindermen.

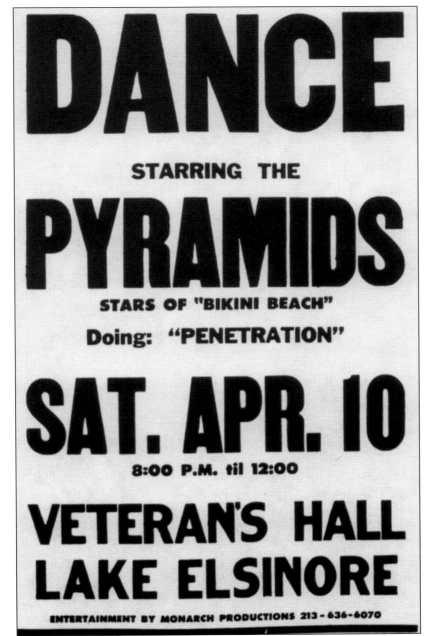

Although Dick Dale & the Del-Tones were featured in the first two American International "beach party" films, the surf band featured in the 1964 film *Bikini Beach* was the Pyramids. While their instrumental "Penetration" had landed in the national Top 20 in March 1964 (the final major surf instrumental hit record of the 1960s), the tune was not performed in the movie. Instead, the band played two instrumentals, "Record Run" and "Bikini Drag," both written and recorded expressly for the film. Although their final studio recordings were made in 1964, the Pyramids were one of the last surf instrumental bands to continue performing into 1965. This poster is for a dance in the Inland Empire city of Lake Elsinore on April 10, 1965.

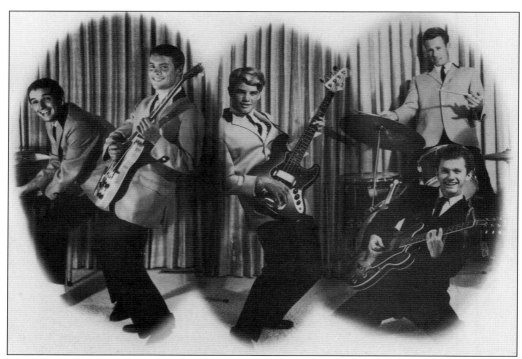

In 1964, the Sandells, from the beachside town of San Clemente, was chosen by filmmaker Bruce Brown to provide the theme music for his new surfing film, *The Endless Summer*. The band had recorded an album titled *Scrambler*, in which the music had more in common with the Ventures than it did with typical surf guitar instrumentals. The title of one of the tracks—the one Brown wanted for his new movie—was changed to "Theme from The Endless Summer." When the film was released nationally in 1966, the *Scrambler* album was given a new cover and title, and the band's name was changed to the Sandals. An endless summer was a fitting way to remember the early 1960s. Shown above are, from left to right, Gaston Georis, John Blakeley, John Gibson, Danny Brawner, and Walter Georis. (Above, courtesy of Danny Brawner.)

CHECKING OUT THE NEXT ATTRACTION

Located in central California, Fresno was a good three hours from the nearest beach. It was here that the Cindermen formed in the early 1960s. During spring break of 1965, while several of the members were still in high school, the band successfully auditioned at the Rendezvous Ballroom and was asked to be the summer house band. Everyone quickly moved south to Newport Beach. After the summer, the band was asked to continue as the permanent house band. The Cindermen also performed at a number of other venues in Southern California for shows produced by radio disc jockeys Casey Kasem, Gene Weed, and Bob Eubanks. At the dawn of the British invasion, the band opened shows for the Rolling Stones, Animals, Dave Clark Five, Kinks, and many others. The Cindermen was the last band to play at the Rendezvous Ballroom. (Courtesy of Douglas Worley.)

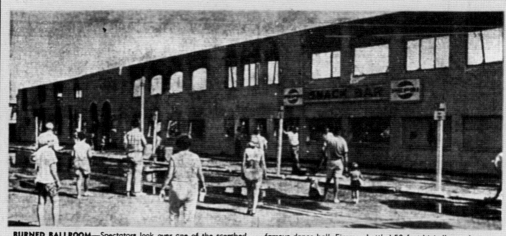

BURNED BALLROOM—Spectators look over one of the scorched walls of the Rendezvous Ballroom at Balboa after fire ruined the famous dance hall. Firemen battled 50-foot high flames for more than an hour before bringing the spectacular blaze under control.

Times photo

Memories of Ruined Rendezvous Dance Hall Go Back 38 Years

BY DON SMITH
Times Staff Writer

BALBOA—The Rendezvous is gone, destroyed by a fire possibly touched off by a smoldering cigaret, but aptly enough, the blaze occurred at a time the old ballroom knew best—the weekend.

For it was Friday and Saturday nights when the block-long, brick structure had played its role since the doors were first opened in 1928.

She didn't die easily, memories seldom do, and despite the searing heat from the 50-foot flames which consumed her, the heavy, thick brick walls still stood when the last flame had been extinguished by firemen.

That, too, seemed appropriate. Neither a 1935 fire which ruined the inside nor thousands of youngsters who used to jam inside every weekend had been able to damage the walls, although at times it probably seemed like the crowds would do the job.

At one time, the ocean front Rendezvous was one of the most popular spots in Southern California, drawing capacity crowds of youngsters every weekend and throughout the summer to dance to the music of big-name bands.

Created Dance Step

More recently, the ballroom had fallen on rougher times but could still draw good-sized crowds although the music was different and Beatle style haircuts and "mod" clothes had replaced the zoot suits and uniforms of the earlier eras.

The dance hall, which once created its own dance step, was one of the few survivors of an earlier era which included such spots as Lick Pier, the Hollywood Palladium, the Palomar (which also burned), the Huntington Beach Pavilion and others.

Throughout the 30s and through World War II big name bands worked the Rendezvous, either for a weekend or all summer while mixing a little work with the pleasure of the beach.

The list of bands is endless but it included almost all of the name orchestras of jazz, swing and dance music.

Along with the name bands came a few others, mostly local groups who wanted the Rendezvous as an outlet and a helpful step on the way toward greater success.

Claude Thornhill, the pianist, first broke onto the national scene from the Balboa dance hall, courtesy of a nationwide radio network hookup which operated the old remote band broadcasts from there.

The following year another piano player named Stan Kenton shifted his band to the Rendezvous from Huntington Beach because of the radio outlet and parlayed a new sound into nationwide fame.

Success Story

The Kenton success story perhaps is the most widely known one and even includes a dance step which became known as the Balboa. Based partly on the staccato style of the original Kenton band, the step also was a development from the band's popularity. The dance floor was so crowded the youngsters had to develop a dance step which didn't require as much moving around as the others then in vogue. Eventually, the step caught on in other parts of Southern California and later spread across the country, still carrying the title of the Balboa.

Perhaps the real heyday of the Rendezvous came during the 1930s and the start of the 1940s with Robert Murphy as the ballroom operator. In three summers the list of bands in for the season included, in order, Thornhill, Kenton and Bob Crosby and his Bobcats.

By that time the war was on and every weekend Balboa became a sea of khaki as thousands and thousands of cadets from the Santa Ana Army Air Base training center moved out on their weekend passes.

Following the war, however, the ballroom began to slump as television began keeping more and more persons in their homes at night.

The six - night - a - week policy for dancing was the first thing to go, and then the supply of name traveling bands began falling off.

Name Bands Dwindled

Rock 'n' roll began taking over but with it came trouble in the form of unruly groups of teen-agers. Finally, in 1957, the Newport Beach City Council ordered the ballroom closed as a trouble spot.

Kenton then reappeared on the scene, took over as manager, won city permission to reopen and brought back a big band. But the era was over despite the nostalgia and a few weeks of slim crowds of those seeking to regain a memory—plus music designed more for listening than dancing — forced Kenton to close down.

With stricter controls on the use of the building, the Rendezvous once again reopened for business with its musical programs aimed at the teenagers—as it had been ever since it opened in 1928.

Lately, the British fad for Beatle - style haircuts, so - called "mod" clothes and Beatle - style music had regained the Rendezvous some of its old popularity with the younger set, at least on weekends.

Oddly enough, it was just such a group, known as The Cindermen, who will go down in history as being the last group to play the Rendezvous.

August 7, 1966, was the second time the Rendezvous Ballroom burned to the ground. The first was on January 27, 1935, only seven years after the huge dancehall was constructed. It was rebuilt within three months to include a 12,000-square-foot dance floor that could accommodate 1,500 couples. At the back of the dance floor was a 64-foot-long soda fountain with a number of couches. A second soda fountain and a couple of dozen more couches lined the mezzanine, which looked down on the main floor. For 38 years, the Rendezvous Ballroom made music history. There are couples who met on that dance floor as teenagers and remain married today. It was a storied structure that played an important, and legendary, role in the early history of surf music in Southern California. (Both, the *Los Angeles Times*.)

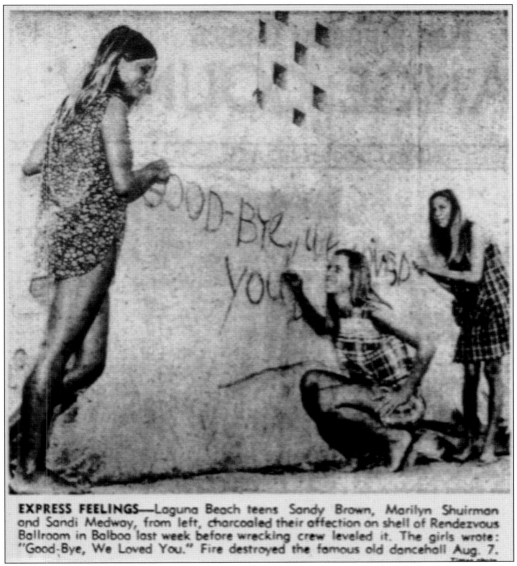

EXPRESS FEELINGS—Laguna Beach teens Sandy Brown, Marilyn Shuirman and Sandi Medway, from left, charcoaled their affection on shell of Rendezvous Ballroom in Balboa last week before wrecking crew leveled it. The girls wrote: "Good-Bye, We Loved You." Fire destroyed the famous old dancehall Aug. 7.

The aftermath of both fires at the Rendezvous Ballroom left three or four of the building's exterior brick walls standing. This was a great help to firefighters in each case, helping to save neighboring buildings. In 1966, two weeks after fire gutted the building, and just before a wrecking crew arrived to raze the structure, three teens from Laguna Beach added graffiti to one of the standing walls. Sandy Brown (left), Marilyn Shuirman (center), and Sandi Medway wrote "Good-bye, we loved you." (The *Los Angeles Times*.)

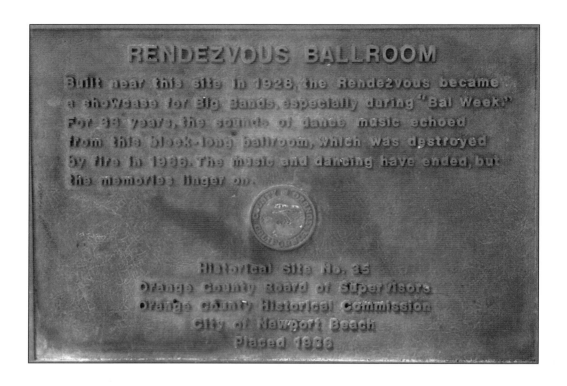

In 1986, the location of the famous Rendezvous Ballroom became Orange County Historical Site No. 35. Currently situated at the southeast corner of where the Rendezvous used to stand rests a historical marker that states: "Built near this site in 1928, the Rendezvous Ballroom became a showcase for Big Bands, especially during 'Bal Week.' For 38 years, the sounds of dance music echoed from this block-long ballroom, which was destroyed by fire in 1966. The music and dancing have ended but the memories linger on." (Below, courtesy of Douglas Worley.)

AFTERWORD
A SECOND WAVE

Surf music did not really end in 1966. The focus of this book is on Southern California, but surf music's popularity expanded by 1964 to include bands and fans from every state in the union (there was also a very fertile period of rock guitar instrumental bands in England and Europe throughout the entire decade). A surf music revival started in Southern California in the early 1980s, with bands such as Jon & the Nightriders, Surf Raiders, and Evasions. Concert stages saw a reenergized Dick Dale perform and record again. Throughout the 1970s and 1980s, there were several "revival" concerts that reunited surf bands from the 1960s.

Then, in 1994, the soundtrack for Quentin Tarantino's hugely successful film *Pulp Fiction* used vintage 1960s surf instrumentals. The soundtrack album sold extremely well, and the movie helped to create an even stronger revival of interest in the musical style around the world. Today, surf instrumental bands are all over the planet. There is a sizeable core audience that grows every year. Several websites are devoted to this music, and large surf music festivals are held annually in places such as Orange County (SG101 Convention), Italy (Surfer Joe Summer Fest), Spain (Surforama), and Belgium (North Sea Surf Festival). You do not have to search very far to find surf music these days.

Discover Thousands of Local History Books
Featuring Millions of Vintage Images

Arcadia Publishing, the leading local history publisher in the United States, is committed to making history accessible and meaningful through publishing books that celebrate and preserve the heritage of America's people and places.

Find more books like this at
www.arcadiapublishing.com

Search for your hometown history, your old stomping grounds, and even your favorite sports team.

Consistent with our mission to preserve history on a local level, this book was printed in South Carolina on American-made paper and manufactured entirely in the United States. Products carrying the accredited Forest Stewardship Council (FSC) label are printed on 100 percent FSC-certified paper.

MADE IN THE USA